The Digital Colour Printing Handbook

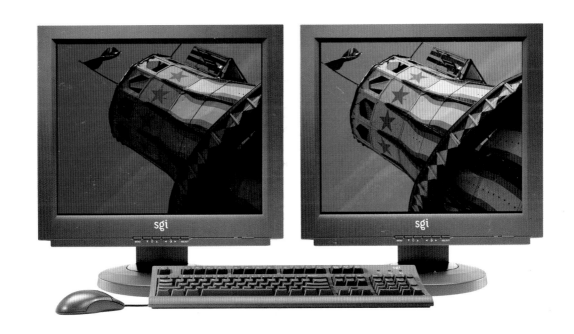

First published 2005 by Argentum,
an imprint of Aurum Press Ltd,
25 Bedford Avenue,
London WC1B 3AT

A catalogue record for this book is available from the British
Library.

ISBN 1 902538 39 0

10 9 8 7 6 5 4 3 2 1
2009 2008 2007 2006 2005

Printed in China

Designed by Nina Esmund

Tim Daly

The Digital Colour Printing Handbook

Getting better colours from your photographs

Argentum

Contents

Why color control is essential

Photographers now have unparalleled control over every stage of image production, but accurate control of color can present a serious challenge.

Although many a photographer will claim that the pursuit of accurate color is not an exact science, this is far from the truth. With a huge variety of software and hardware gadgets available, it's now possible to have confidence in your working methods and your own ability to correct and enhance your color images.

With the technological development of many devices now starting to plateau, digital tools produced for the photographer by hardware and software manufacturers are starting to display common characteristics. Yet these are still early days for creating and controlling accurate and predictable color, as many a keen digital photographer will know to their cost. The use of unfamiliar processes from initial capture to final print-out can result in bright colors being lost for no clear reason.

The Digital Color Printing Handbook sets out to provide a reassuring guide to the essential methods for controlling color from capture right through to output and assumes minimal prior skills or knowledge.

Identifying key stages in the management of color, this book suggests that photographers should make sure they understand essential techniques before creative production takes place.

Starting with the essentials of digital color and how it's recorded, the book takes an impartial look at different hardware and software tools, so you can make informed judgements about your workstation and method of working.

Rather than present creative color control as a complex science of numbers and calculations, **The Digital Color Printing Handbook** uses plain English and identifies the simplest and most effective methods for maintaining control.

A raw unprocessed file needs careful attention in your image editor before color starts to look attractive

With maximum image quality remaining the top priority, the author aims to strip away unnecessary jargon, long-winded processes and everything that doesn't contribute to a visually attractive result.

After examining how to control, correct and enhance the native colors in a digital image, the book goes one step further and presents a series of simple color recipes. In addition to classic color styles and post-production methods, **The Digital Color Printing Handbook** reveals a series of simple and unique color styles for adding another layer of interest to your already accomplished photographs.

Reflecting the meteoric rise in the use of digital cameras, the book assumes this will be the predominant mode of capture and investigates all the quality control issues that a new user can often find intimidating.

With the increase in digital camera capture has come a new set of technical demands: how to manage color through camera use, exposure and desktop development.

Drawing our attention to the concept of the raw file, straight out of the camera's memory card, **The Digital Color Printing Handbook** guides you through a reassuringly simple method of transforming uninspired raw files into vivid eye-catching exhibition prints.

Showing both start and end points for all creative projects, the book aims to be an inspiration to a new generation of creative photographers who want all the flexibility of digital, without the distractions of gimmicky software edits. The real business of squeezing the very best out of your image files begins now!

Chapter 1

HARDWARE TOOLS

Choosing a workstation

The kind of computer you choose is much less important than a good quality desktop printer, but you should invest in a system that is easily upgraded as your expertise increases.

Many keen photographers will be juggling with image files measuring 20–50Mb in size, and these place little demands on the humble home PC. When looking to invest in a workstation, the following items need careful consideration.

Processor speed
It's not essential to have the fastest processor in your desktop, as anything over 750Mhz will suffice. A much better bet is to spend your budget on extra memory.

Random Access Memory (RAM)
RAM is the component in your PC that juggles your data while you work. Too little RAM, and your PC has to write information to slower spinning hard drives, ultimately slowing you down regardless of the speed of your processor. Invest in 500Mb as a minimum, but if you can stretch to more, even better.

Hard disk storage
Although your image files are best stored on removable media, a good alternative is to install a second high capacity hard disk in your PC. Opt for a 100+Gb size, so you can archive all your files without using your PC's main system disk. Hard disks are rated by speed, with faster models rotating at 9600 revolutions per minute (rpm) taking less time to access and open your files.

Internet connectivity
With so many software updates available only on the web, internet connectivity is now absolutely essential. Opt for a built-in modem and virus protection software, so you can connect to a simple 56k dial-up service and minimize the risk of infection. Depending on your location, you may also be able to connect to cable broadband services, without the need for a built-in modem. Another alternative is the ADSL modem, a plug-in peripheral that delivers broadband services.

Disk drives
A built-in CD writer is essential for loading software and writing your data to CDR disks. Increase your drive's flexibility by buying third-party writing disk software such as Roxio Toast.

Ports
To make the best use of digital cameras and printers, your PC should have a variety of easily accessible ports. Many older PCs were not designed for today's hot-swappable generation of screenagers, and have all the most essential sockets stuck right on the back of the case. Better PCs have USB and FireWire ports on the front or side, or even on the keyboard for easier access. Extra expansion slots are useful for adding converter cards for older plugs.

Apple Mac or Windows PC?
Now, given Apple's increase in the consumer market share, there are even more reasons to think about an alternative to Windows. With closer than ever technological links with Adobe, Apple computers are designed to run Photoshop faster and smarter. Now built around a much more stable UNIX operating system, Apple computers are still favoured by most graphics professionals.

If a Windows PC is your choice of workstation, opt for a reputable brand such as Dell or IBM, as this will guarantee consistency and less variation in the kind of components used, which, in turn, will make for fewer hardware compatibility issues in the future.

Ports, plugs and leads

If you're confused by the differences between USB, FireWire and SCSI, then you'll need to catch up with the fast-moving world of data transfer.

If you are using an older PC, chances are that you'll encounter an incompatibility problem sooner or later. As digital cameras and scanners get better at capturing more and more data, the speed at which this is transferred to your PC becomes a real issue. Ever since personal computers were designed to link up with external peripherals like flatbed scanners, external disk drives and digital cameras, data transfer rates have soared through the roof.

Software compatibility

The biggest cause of peripherals conflicting with your PC hardware is entirely down to software incompatibility. Even if you have the right lead in the right port, there's still a chance that the device software wasn't designed to work on your current operating system.

Hubs and adaptor docks

Hubs are essentially like double or triple plugs and allow you the convenience of connecting a desktop terminal to more than one device at a time. Although the data transfer speed will be halved if and when two devices are used at the same time, the convenience factor far outweighs the limitations. For connecting older peripherals such as Serial or SCSI, useful adaptors can be added to the dock, so you can carry on using older gear.

Installing upgrade cards

It's not the end of the world if your PC doesn't have a FireWire or USB port, as you can buy and install a card for very little. All desktop computers are designed with vacant PCI slots so that you can add extra hardware as and when you need to, and if you are confident about wiring a domestic plug, a DIY installation shouldn't pose a problem. After disconnecting your power supply and removing the desktop case, you'll easily spot the vacant slot and plug. All cards are supplied with easy to follow instructions to protect both you and your computer equipment.

SCSI

SCSI is the oldest system and is available in four variations: the original and slowest SCSI-1, SCSI-2, SCSI-3, and the fastest of them all, Wide Ultra SCSI-II.

Unlike USB, SCSI is not hot-swappable, meaning you can't unplug or plug in peripherals without shutting down your PC first. SCSI devices can be daisy-chained to one another but there is a limit on the overall cable length and each device needs to have a set identity number before use. In ideal conditions, faster SCSI variants deliver between 10 and 40 mega bits per second, or Mbps.

USB

Found on most digital cameras and flatbed scanners, USB comes in two variations: the older USB 1.1 and the latest USB 2.0. Unlike the myriad differences within the SCSI range, USB is essentially a one-plug-fits-all system. It's less fiddly to connect and you can also remove plugs without powering down your system. Even more exciting is that the power supply can be delivered via a USB port, so peripherals can draw supply from your PC rather than another mains plug socket. The original USB 1.1 system transfers 12 Mbps, with the latest and still-emerging USB 2.0 delivering a blazing 480 Mbps.

FireWire

Sometimes referred to as IEEE 1394, FireWire offers data transfer at lightning speeds for high-end digital cameras and camcorders.
Like USB, it can also deliver juice to an external device, but at a far greater 15 watts supply, and is also used for linking external hard drives and storage media. FireWire is standard on all recent Apple computers but generally found only on the top PC manufacturers such as Sony, Compaq and Hewlett Packard. FireWire transfers at up to 400 Mbps.

Digital cameras

Digital cameras are nowadays the easiest way to produce top quality image files for processing on your PC, but you need to know exactly how they work to get the very best results.

Working with a Halina or Hassleblad film camera will produce the same kind of capture process, but not necessarily the same end result. The same can be said about budget digital compacts and top price digital SLRs. Using many of the same controls and settings which inevitably influence final image quality, it's essential to base your shooting on sensible settings. Instead of using light sensitive film, a digital camera has a built-in sensor called a charged coupled device, or CCD for short. The sensor is constructed from millions of tiny light sensitive cells, arranged in a grid-like pattern. With most cameras, each cell is responsible for creating one square pixel in a digital image. When light passes through the camera lens and hits each individual sensor cell, minutely different voltages are created. The sensor then converts these signals into different brightness values, but using an entirely digital scale. After each photographic image is taken, the sensor assembles all the individual cell values into pixels which are then arranged in a mosaic-like grid. In digital photography, the more pixels you have in your image file, the bigger and better the quality of print. Digital cameras are therefore sold with sensors which have a different number of pixel-making light sensitive cells. The standard measurement used for describing the pixel dimension of

an image is called the Megapixel value. This stands for one million pixels, or M for short, and the value is derived by multiplying the number of pixels across the horizontal and vertical axes of a digital image. A camera with a 2.1M sensor creates images with a pixel dimension of 1800 x 1200. At the bottom

A basic digital compact will have a fixed range of settings which may not allow you to create your own preferences.

end of the market are cameras with sensors capable of producing less than a million pixels, typically 300,000 which makes images of 640 x 480. These are only suitable for web or onscreen use. At the top end of the scale and at ten times

the price are cameras capable of producing in excess of 6 million pixels and very high quality results.

ISO speed

ISO speed is a term used in traditional photography to indicate the light sensitivity of film materials. With conventional film, special light sensitive emulsions are manufactured to work successfully under bright, normal or low light conditions with speeds indicated as ISO 50, ISO 100 and ISO 800 respectively. As each of these values doubles, the sensitive material needs half the amount of light to work effectively. If the ISO value is halved, e.g. from 400 to 200, then twice the amount of light is necessary. The best quality images are produced with both digital and conventional film by using the lowest ISO setting or materials, such as ISO 100. Basic digital cameras are designed with just one ISO speed setting, such as ISO 200, but better digital cameras have a range of speeds that can be set to match picture-taking conditions, even for just one shot. Inextricably linked to ISO is an aspect of digital image quality called noise. When high ISO settings are selected and images are shot under low lighting conditions, insufficient light causes the creation of error pixels called noise. To fill in the missing data, the sensor creates a bright red or green pixel

and lots of these produce a visible loss of image detail and sharpness. Noise is most visible in the shadow areas of a digital image and the effects can be minimized, but not removed entirely, by filtering out in a good imaging application like Adobe Photoshop. Many professional photographers avoid noise by opting to shoot conventional film in low light, which is then scanned afterwards using a specialized film scanner.

White Balance

Unlike the traditional complexities of balancing film stock to the color temperature of light, the White Balance controls on a good digital camera are effectively a built-in color temperature meter and a complete box of color correction filters. If the results of shooting under indoor domestic lighting have ever turned out disappointingly orange, then digital cameras have a useful built-in control to solve this problem. Traditional photographic film is manufactured to work within a specific range of natural daylight and will produce strange and unexpected colors when shooting under artificial illumination. Digital cameras have a White Balance function which provides invisible color correction for the effects of fluorescent tube or domestic tungsten lighting. The Auto White Balance setting is perfectly acceptable for most photographic situations, including daylight shooting, but professional photographers should seek a camera which has precision color temperature controls using the Kelvin scale (K) for color-critical assignments.

Access to user defined settings is offered through the rear LCD preview screen of a digital camera

Color space

The term color space is best thought of as a color palette. Many good quality digital devices such as printers, scanners, monitors and digital cameras can be set to create digital images using a common color space or palette. The advantage of working within a consistent color space is to avoid color change when images are transferred between different devices. Each color space is defined by its own unique number of different colors, and if images are changed from one space to another, some color conversion may not match. The sRGB color space is a general palette used in most digital cameras, but better cameras can be set to shoot in the Adobe RGB (1998) space, which draws upon a larger color range. Professional image editing software like Adobe Photoshop allows you to manage images produced under different color spaces and minimize the visible damage. If your

digital images constantly lack color or brightness, then it's worth checking the color preferences of your imaging application to see how your files are being interpreted.

Image size and resolution

Many digital cameras allow images to be created in more than one size. This is especially useful if the camera is to be used for both print and web end products. There's no advantage in shooting an enormous image such as 1800 x 1200 if the end use is for a web page or email attachment. A smaller size option, usually 640 x 480, is best selected for these uses. When a reduction in image size is set, more images can be stored on the camera's removable memory card. The drawback in shooting smaller images is that they will not be suitable for photo-quality print-out. If subjects are to be photographed for both web and print purposes, shoot on the largest image size available, then make a smaller second version by re-sizing your image in Photoshop or another imaging application.

Sharpening

Sharpening is nothing more than increasing the level of contrast between edge pixels. In a soft-focused image, colors are muted at the edges of shapes, but in a pin-sharp example colors are more widespread and have inherently more contrast. Digital camera images are often soft, owing to the anti-alias filter fixed in front of the sensor which prevents jaggy staircasing. All images benefit from software sharpening, which should be applied at the final stage just before printing. When applied too early, error pixels, known as artefacts, which are

caused by sharpening, are magnified and destroy image quality. Every image should be sharpened after resizing in either direction, as interpolation causes an inevitable loss of original image detail. Photoshop is supplied with four sharpening filters: Sharpen, Sharpen More, Sharpen Edges and the Unsharp Mask, all of which can be applied to the image overall or to a smaller selection area. Only the Unsharp Mask filter can be modified to address the exact problem posed by individual images. The sharpening function on a digital camera usually offers high, normal and off options. The filter works by increasing the contrast at the edges of strong shapes within an image. The filter should only be used if files are to be printed directly or used onscreen without any

further processing or manipulation. Should sharpened images be manipulated further, artefacts will become apparent. For high quality print work and commercial reproduction, leave the sharpening filter off, as this can be applied in Photoshop at the very final processing step.

Saving and storing

On a digital camera, there are usually three or more JPEG quality settings, which are primarily there to let you cram more images onto a memory card. Lowest quality JPEGs will not be good enough for fine printing or creative enhancement. A much better option is to select a high quality JPEG setting and buy a bigger memory card. Never shoot exceptional photographs as low quality JPEGs, as the quality can't be enhanced at a later stage. This downsizing of digital data is called compression and is designed for faster network transmission and less demand on storage media. There are two different kinds of compression, lossy and lossless. Lossy compression is used in the JPEG format and results in a significant loss of image detail and sharpness each time the file is resaved. This familiar damage looks like a crude pattern of disjointed blocks appearing in previously detailed areas of the image. Lossless compression, as used in the TIFF format employs a different mathematical mechanism to discard data without causing visible damage to your image. The savings are not as great as low quality JPEG files, but sharp detail is preserved. To visualize this mathematical routine, imagine a compressed TIFF file as a rolled-up photographic print and a

JPEG as a folded photo print. Once opened, the TIFF will show no signs of damage, but the lossy JPEG format will bear all the 'crease' marks of a crude method of easier storage. With cheap and plentiful high-capacity data storage available, there is no reason to compress images unless they are destined for network end use.

Camera presets

Straight out of the box, many cameras may well have default settings that cause more problems than you'd expect. In essence, a preset camera control will apply a Photoshop-like edit to the image on the fly which cannot be removed at a later date. Sharpening, contrast or increased color saturation are the three most common options, and these should all be turned off at the point of capture.

Contrast is best defined as the amount of strong black and pure white in a photographic image. In certain lighting conditions, such as a foggy or overcast day, natural light is considered low contrast, as it has many shades of grey but no strong blacks or whites. These circumstances will produce photographs lacking in strong tones and colors. Many digital cameras have contrast adjusting settings to compensate for these naturally occurring situations. Yet, despite their usefulness, far greater control can be exercised using imaging software. Once a preset has been selected and imposed on an image file, there's no going back, but with later software-imposed adjustments, there's always the possibility of reverting to your original file if mistakes are made.

A digital SLR is designed to offer you customized control over color balance, color space and a range of file formats to save and store your image.

Custom White Balance

Found on digital SLRs and advanced compacts, custom White Balance settings allow advanced photographers to create and store a calibrated setting for use on color-critical assignments. Like light, color can be precisely measured, and different light sources can be calibrated on a color temperature scale measured in Kelvins (K). Although it isn't evident to the naked eye, each different fluorescent tube product is made with a specific color. If you know its exact color temperature, you can calculate the precise custom White Balance setting. Color temperature can only be measured using a special color temperature meter, an expensive option for all but the serious pro photographer. Yet with the use of your LCD preview screen, you can easily check and refine your custom settings before starting the shoot.

Despite their technical nature, White Balance controls can also be used in a creative way to enhance the color of a scene. Shooting tungsten-balanced film in daylight creates a weirdly attractive blue colored image, where flesh tones are cold but stylish. You can easily mimic this effect by selecting the tungsten setting and shooting in daylight.

The range of results from different camera presets can be seen in these vertical strips. From left to right: high Contrast, no presets selected, Auto Contrast, Sharpening On. All four variations demonstrate a marked impact on color and image contrast.

Liquid crystal display monitors

The latest type of display unit is the LCD, but you need to buy a good brand to be certain of a reliable window on your workstation.

Although the rate of LCD monitor development has been fast over the last two years, you'll still need to pay top dollar for a good quality model. LCDs are best positioned perpendicular to the viewer, and colors will change if you move your own angle of view, so you need to ensure that your immediate environment is free from bright lights and unwanted reflections.

To maintain the best quality, look at the screen straight-on and avoid tilting it halfway through an editing sequence.

Like all monitors, it's essential to color calibrate once it's out of the box, setting the white point and individual colors.

Positioning your screen

After carefully tweaking your monitor settings, there's simply no point in positioning your screen opposite a bright window. Reflections off your screen will always cause havoc with color accuracy and will make image colors look bland or washed out. If you've got control over your environment, then don't sit next to walls painted a vivid color or wear wild colored clothes yourself, as these will both reflect badly on your monitor.

Screen resolution

Although super high resolution screens have been on sale for some time, it's important to work with the most comfortable setting. Even though your graphics card and monitor may support billions of colors and a display resolution in excess of 1600 pixels, there's no reason to work at top quality. At super high screen resolution, software and tool icons become tiny and very difficult to view over a lengthy edit.

Hoods

It's now possible to purchase clip on hoods for all sizes of screen, including flatter panel LCDs, making them much less vulnerable to reflections. As with a repro quality CRT monitor, shading your screen really helps your display to look consistent and reveal more vivid colors.

A top of the range SGI monitor offers vivid colors and ultra high resolution

PROS	CONS
■ Very small footprint compared to older CRT models.	■ At least three times more expensive than CRTs.
■ Little heat is emitted during use	■ Can be difficult to position to avoid unwanted reflections.
■ Screens are flat and do not barrel in shape like older CRT models	■ Surface coating can be vulnerable to damage from fingers
■ Actual display area can be larger than CRTs in size for size measurement.	■ Only top quality LCDs offer the same kind of vivid color display as CRTs
■ Less warm-up time compared to CRTs	■ Cheaper models offer poor brightness and contrast, making images look dull

Cathode ray tube monitors

The cathode ray tube monitor is still regarded by many as the best way of displaying accurate color and contrast.

With many photographers still favouring Trinitron-tube CRT models like the Blue LaCie, you'll be surprised at the low cost for this professional piece of kit. Fit a wraparound black hood which works like a lens shade, and this will prevent stray light from influencing your judgement.

With many budget LCDs not offering anywhere near the same kind of image quality as a CRT at the same price, be guided by manufacturer reputation rather than innovation.

The monitor is by far the most important piece of kit in your workstation, aside from your output device, and will determine how accurately you are able to color balance and contrast adjust your raw files.

Recommended makes

Despite the proliferation of monitors, you should only purchase devices made by a company with a long standing reputation in this field. Sony, Mitsubishi and LaCie are three prominent manufacturers whose models easily interface with color management applications. Many displays, regardless of make, use a standard hardware component, the Trinitron tube, which is dependable over time.

A hooded CRT monitor is still a popular choice with professional photographers

Hardware calibration

For a little more of your budget, a useful addition to your CRT is a hardware color calibrator. Devices such as the Spyder work by taking readings from the actual surface of your screen, rather than relying on your own subjective judgements.

The hardware calibrator is supplied with its own software controls, which provide a simple step by step method of detecting colors. Once measured and evaluated, the device produces a profile which is stored in your desktop PC and referred to on restart.

Resolution

Although many graphics cards support billions of colors, there's no reason to make use of anything beyond the million range on your monitor, as all current output devices only work with a 24-bit palette.

PROS

- Best quality and value for money
- Easier to use under normal room lighting

CONS

- Needs at least 30 minutes warm up time before tubes emit constant color
- Will need recalibrating regularly to keep color display accurate
- Can lose ability to describe color accurately after a few years, or after intense use
- Can 'burn out' if a screensaver is not used
- Produces heat which may make your working environment uncomfortable over time
- Larger models are extremely heavy and can be difficult to move and vulnerable to damage in transit
- Many displays still produce a slight barrel distortion onscreen

Professional inkjets

A top of the range desktop inkjet still costs half the price of a digital SLR and is the most crucial part of your workstation.

Designed to operate at much higher levels of control in a professional workflow, this kind of device will produce the highest quality output of all. Equipped with seven separate ink cartridges, including a light black for better tonal gradation, this printer will produce true photographic quality output.

Inside the case is a complex printer head, able to emit ink in different sized dots. Different to basic inkjets which print with a fixed sized dot, the variable dot printer provides a more convincing end product. Working at output resolutions up to 5660 dots per inch, ink is much less visible on the printed page.

To provide commercial photographers with light fast prints for resale, the professional inkjet is designed to use pigment ink cartridges and can also be used with a range of specialized third party products such as Lyson Small Gamut or Quad Tone inks.

Software controls offer more flexibility to manage accurate color and neutral monochrome output. With many photographers using inkjets to create monochrome prints, creating cast free results can prove a difficult challenge. For maximum light fast prints, the printer is best used in conjunction with purpose made archival papers rather than cheaper general purpose materials, and should never be used with budget materials.

Built to meet
the higher expectations of a professional photographer, the Epson 2100 is a top of the range desktop inkjet printer.

Connectivity

Unlike laser printers, inkjets are sold without built-in memory or network cards, and are designed primarily for single workstations. However, through the use of a software raster image processor (RIP) residing on a networked printer server, the printer can be shared easily amongst a group of users. Using a software RIP will inevitably present another layer of color management issues, but can provide a flexible solution to managing heavy use. Any PC can be used as a print server, and is an ideal use for an older machine. An even cheaper option is to share your printer via a USB hub.

The Epson 2100

Many professional photographers choose this printer for its sophisticated software, speedy output and seven ink colors. It produces exhibition quality prints at high resolution and works with a variety of media, including roll paper, panoramic sheets and the thickest of cotton fine art papers. When used with pigment inks and acid free paper, prints are predicted to last over 100 years.

Resolution

When applied to a printer, the term resolution should not be confused with the resolution of an image file. In a modest quality inkjet printer, the printer heads will be able to emit ink as a single sized droplet, but in better models, droplet size can vary to include a micro fine option.

Variable sized dots define a top quality printer, as this additional function aids the reproduction of fine detail and sophisticated color gradients without visible signs of banding.

Close-up, bigger dots are more evident in highlight areas, but this is much less noticeable in higher resolution devices.

The higher the resolution, the finer the print it can produce, but any inkjet working at 1440 dots per inch will produce photo quality output providing the right ink and paper are used.

Color palette

With many home office inkjets still designed with a four color ink cartridge, you'll need a better type of device to achieve photo quality results.

Most photo inkjet printers use a six color pack: the four standard colors of cyan, magenta, yellow and black, plus light cyan and light magenta. These extra two colors really help to provide better skin tones and smoother color gradients found in photographic images.

Better professional inkjets like the Epson 2100 model have an additional seventh color: light black, which helps create smoother tonal transitions when working in greyscale or duotone modes.

Four color inkjets are really only suitable for printing solid graphics such as charts and line art for office reports and newsletters.

Pigment inks

Responding to the first wave of anxiety about the permanence of digital printing, ink manufacturers have developed colors based on pigments rather than dyes. Dye based ink is found in all non photo quality inkjet cartridges and all budget third party refills. Cheaper to make but quick to fade, dye ink should never be used to print an image for resale.

Pigment inks are made from lightfast pigments and are more expensive to buy, but independent research has shown that prints will last longer than conventional silver based color photographic prints.

The downside to pigment inks is lower color saturation, which is hardly noticeable in portraits or landscapes, but mutes vivid colors.

Fixed sized dots, above, do not produce as convincing an illusion as different sized dots

The more colors your printer has to work with, the more realistic the end result

Pigment inks produce muted color results but extend the lifespan of your print

Photo inkjets

Equipped with a six-color ink pack, photo realistic inkjets are now made by all the major manufacturers. Aimed at the advanced user, they are capable of producing a better quality output than an office inkjet.

Now more versatile than ever before, photo realistic inkjets are designed to provide an all-round solution to your printing projects. Many are built with integral memory card slots, or a direct camera-to-printer USB connector, offering you the option of using the unit as a stand-alone direct printer without the need for a PC.

With the emergence of a wide variety of print media, a good printer will be able to output to printable CDR disks and operate with roll paper feeder, as well as custom sized papers and panoramic sheets for large scale work.

Photo inkjets are sold on the basis of their maximum resolution and connectivity options, with better models providing over 4000 dots per inch output in variable sized dots. They hook up to your PC via the standard options of a universal USB port, FireWire or even a Serial port for connecting to older computers.

Sold at a third of the price of a professional inkjet, this kind of desktop device is an ideal starting point for a fledgling digital photographer. Many mid-range models can be used with different inksets, with both dyes and pigment sets available for different end results.

Unlike desktop laser printers, inkjets can be used with thicker media, such as watercolor paper and specialized archival media, and offer more potential for creativity.

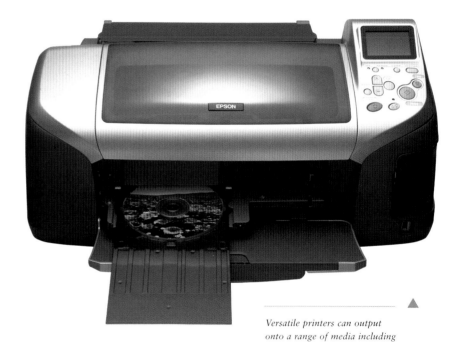

Versatile printers can output onto a range of media including CDR disks

Software tools

All desktop inkjets are supplied with self-correcting software to help maintain them in maximum working order. Left unused for some time, printer heads can become blocked, but are easily cleaned with a simple software command. Printer heads can also become misaligned when working with thick or textural media, creating visible lines and banding across print-outs. Left unattended, the output quality will remain poor, but re-alignment can easily be fixed through printer software.

Microchipped inks

Many printers use read-only microchipped ink cartridges which communicate the level of remaining ink to the printer software. Despite the obvious advantages of this when working on large scale prints or a run of matched prints, ink cartridges are often deemed 'empty' by your printer software before they really are. A good solution to avoiding waste is to use a continuous ink system, which delivers ink via larger self-replenishing reservoirs that sit outside the printer unit.

Color laser printers

Offering top speed output and all the advantages of connecting through a network, color laser printers are much more useful than you might think.

Despite being unable to use a wide range of print media like an inkjet, the desktop laser printer can be a valuable tool in any design studio. Built using an entirely different mechanism for delivering color onto paper, a color laser printer uses separate dry dust toning cartridges.

Despite being bulkier than an inkjet and operating at a higher temperature, lasers are often used as a proofing device, with designers taking advantage of their speed and predictability rather than high resolution and color accuracy.

A good color laser can be purchased with a built-in Ethernet network card, allowing easy connection to many computer users through a local area network.

Good models also offer built-in memory, so you can spool data to the printer and store fonts there too. Lasers are cheapest when purchased with an A4 or Letter maximum print size, and larger A3 devices double or treble the cost.

The downside of laser printers is the obvious shortfall in image quality compared to a fine inkjet print, but if your output is destined for presentation or office rather display or exhibition, this is not an issue.

Consumable costs are more expensive than inkjets, owing to the use of high capacity toner cartridges, but print costs are cheaper in the long run.

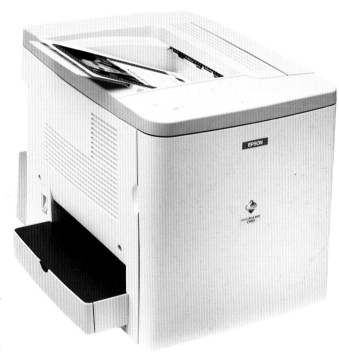

The color laser printer is a dependable device for producing artwork without the need for photographic quality output

Paper choice

Unlike inkjets, lasers are restricted to a maximum paper thickness, usually around 100 gsm. The best results are obtained by using a slightly coated bright white media, as this helps to enhance shadows and color saturation. However, perfectly acceptable prints can be made using standard white copier paper, which helps to keep the costs down. Some printers can also output to specially designed transparent media.

Postscript options

Although it's not essential to output images to a Postscript printer, this can be useful when printing vector graphic work. Postscript is a universal printer language that enables files and fonts from a wide variety of souces to be scaled and output at high resolution.

Graphic files created using vector image applications like Illustrator are output with greater accuracy on a Postscript device.

Direct printing

Connecting straight to your camera, a direct printer can save you time and effort but still produce great results.

Recently, great advances have been made in the design and quality of direct printing units, those curious peripherals that print directly from your camera or card without the need for a PC. Although originally targeted at photographers who were less concerned about manipulating their digital files before print off, the newer models create top quality results that would satisfy the most discerning of cameramen.

With many boasting a six color ink cartridge printing up to 4800 dpi resolution, direct printers are capable of producing the level of quality output associated with photo inkjets. Built for convenience and portability, they give you the quickest results from your camera or memory card without needing to use your digital workstation. Yet, despite being designed for the family digital camera user, a direct printer can provide a useful proofing tool when out on location, working with a client or trying to manage a large print order promptly.

All the major hardware players have a direct printer within their product range, and there are many different types of technology to choose from. As standard, they all print directly from your camera using the universal PictBridge or USB Direct Print protocols, but fewer models actually accept memory cards directly. All are fitted with a USB input terminal, so cameras and other devices can be connected without the need for a PC. Most printers in the range use dye-sublimation technology to create color prints, an effective process for reproducing color, but not in the same league as a top quality inkjet printer.

The cost of consumables for a direct printer compared to an A4 photo inkjet and a 10 x 15cm photo print from an online photo processors makes it a more costly method of output, but much more convenient if speed is the issue. Direct printing manufacturers have designed their consumable products in a simple one-box ink/dye and paper pack, offering much less choice of materials than you would expect from a quality photo printer. A typical consumable pack for a direct printing device is still comparable with the cost of a roll of 35mm and a typical develop and print package.

Most direct printers produce index-type prints with thumbnails so you can make a decision on which to print. Many also offer the option of printing passport-sized images or multi image layouts on a single sheet of paper. Borderless prints, the firm favourite for family albums, are less universal, and many systems use paper with tabs or perforated edge media which need to be cracked off after the print has dried. The Epson PictureMate produces clean borderless prints that look and feel like a commercial print and fit straight into standard family photo albums. Although the disadvantage of direct printing is the loss of control offered by the image editing phase, many direct printers perform sophisticated onboard image processing.

Working with the Exif data for each image file, saved and stored by your camera at the time of shooting, the printer interprets Exif records such as white balance, sharpness and contrast and makes adjustments to create fully enhanced prints.

Printers can also respond to a DPOF compatible camera, allowing files to be tagged and print quantities set on your camera before connecting up to your direct print device. Bearing in mind the usefulness of Exif data, there's simply no reason to select onboard camera enhancements such as contrast and sharpness, so they are best switched off.

Useful for seeing instant prints from a studio session, a direct printer can be used to check on lighting ratios in much the same way as Polaroid proofing film. For portrait photographers, the direct printer can be a valuable way of presenting your sitter with a proof or an instant print to take away.

The Epson PictureMate offers borderless 10 x 15cm output at super high resolution ▶

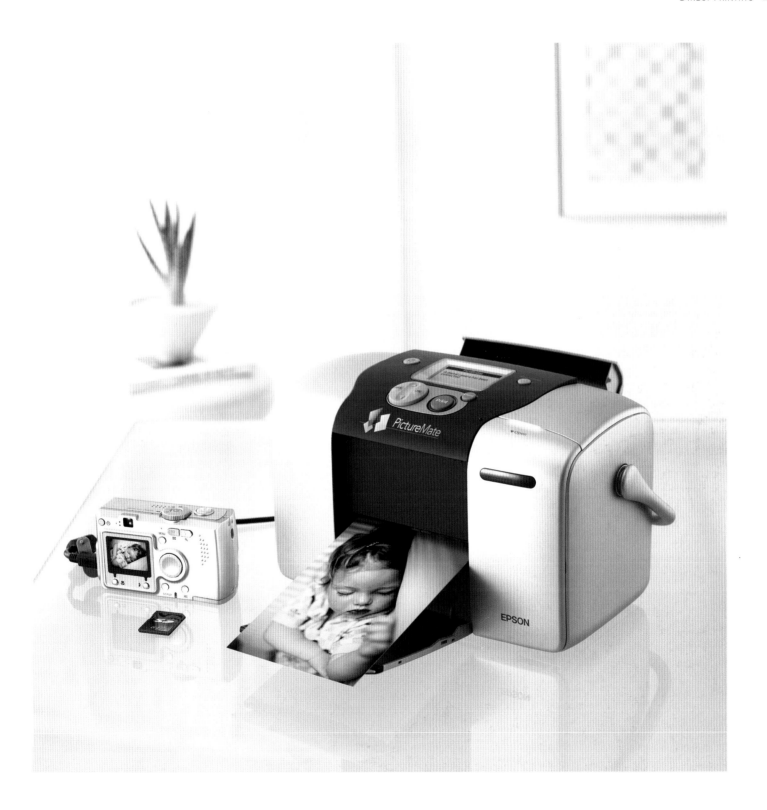

Continuous ink systems

With a few simple adjustments, you can turn your humble inkjet into a more dependable workhorse, and keep your printing costs down without sacrificing print quality.

Designed by a handful of third party consumable companies, the CIS option is now a firm favourite with many busy photographers. Lyson in the UK and ConeTech, an innovative company based in the US, both produce excellent CIS products together with their own good quality ink products. The CIS works by replacing the standard inkjet cartridges within your printer with a simple plug-in series of feeder tubes, connected directly to large reservoirs of color. In practice this means that you can always see what is happening to your ink quantities before they run out, and considerable savings can be made on the cost of your inks.

Although the better CIS kits are far from cheap, with many systems costing close to the price of your original printer, savings can occur if you are a frequent user and abuser of ink. After the initial trial period of inkjet printing is very much over, most cynical photographers are well aware that some profits are indeed made from consumables sales and therefore the ongoing costs of running a home inkjet printer can be considerable if you choose to be a discerning producer of fine prints. Other cost effective alternatives to buying branded inks, such as do it yourself syringe type refills or cheaper brand replacement cartridges are not really worth pursuing. Employing cheap and unstable dyes offers no guarantee of consistency or lightfastness; you really do get what you pay for when you opt for the mail order specials. In conclusion, any solution that offers a reduction in running costs combined with excellent quality is very much welcome, but these are few and far between.

Like many developments in desktop printing, the CIS is largely based on a similar ink delivery system used in large format printers, that of a print head connected to substantial reservoirs of ink outside the moving mechanism. The original desktop design is so compact and desk friendly, it compromises such a small footprint by trading off limited space for bulky ink cartridges. With many of the top printers from Canon and Epson now sporting individual color pods, space is still at a premium under the bonnet. There's nothing as annoying as an ink color running out when you have just started getting into the groove of printing, but this can be avoided by the use of a CIS.

Setting up your CIS

Once your purchase had been made, your CIS arrives in a small shallow box. On first inspection, the contents look largely like a do it yourself kit for minor cosmetic surgery: a syringe, various clear plastic tubes and a modified printer cartridge. The system works by fooling your inkjet into thinking it has accepted the transplanted cartridge as one of its very own. However trite this may sound, this is no mean feat as most modern printer cartridges are now microchipped and are often written to as well as read from by your printer software to prevent re-use and recharge.

Gone are the bad old days of unchipped cartridges when it was possible, when not concentrating too much, to insert the wrong cartridge perfectly well into the wrong printer. With ink colors lying in different positions inside the pod, wonderfully unpredictable results were achieved as the cartridge dropped magenta onto your paper when you had told it drop cyan. Ridiculous as this may sound, the same problem can still occur when setting up your CIS, but more of that later. Lyson's own cloned cartridge is cleverly designed with a read-only chip, so the printer software can't suddenly insist on a cartridge change when it's totalled up the last fifty sheets of frenzied printing activity. Instead, the chip allows the cartridge to remain and be re-used without trouble; all you have to do is keep your eye on the ink levels elsewhere.

Once out of the box, instructions must be followed to the letter; there's no room for creative interpretation. When you're ready to start, allow a good hour to complete the task and give yourself a large clear working area. The good news about CIS conversion is that it's

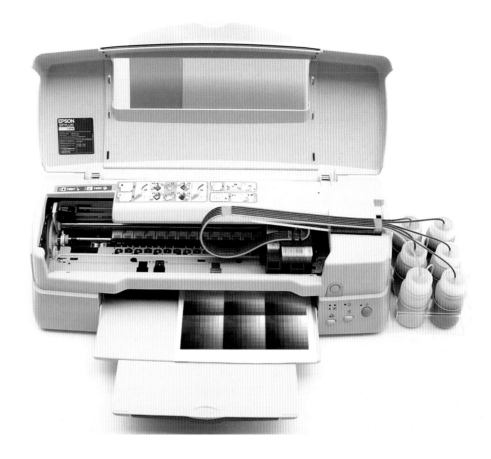

The Lyson CIS package has developed a good reputation over a number of years of development. Inks are stored outside the unit and delivered through a network of capillary tubing directly into a dummy printer cartridge

completely reversible should you want to revert back to your original factory made printer. After whipping out the original ink cartridges, it's advisable to use a head cleaning product that purges the printer of its native ink and paves the way for the new product. If this is not available, it's very well worth using your printer software utility to clean the printer heads and make sure that all is well beforehand. It goes without saying that ink from two sets of products will cause you an immense headache if you run your printer under tightly controlled color management conditions. The CIS is equipped with a syringe which works as a mini-vacuum

pump to clear all of the plastic tubes leading from the ink reservoirs to the printer head. With a clever use of clamps and valves, the vacuum pump removes all the air from the tiny ink line, allowing each chamber of the cloned cartridge to fill with ink and no air bubbles. Each tube is labelled with a color, so you don't connect cyan to magenta by mistake, but, most importantly, you must take great care in getting the sequence of colored reservoirs correct in the external bottle rack. After the first color airway has been primed, the remaining colors take much less time to set up. Once connected, you will have a cartridge linked to six thin veins of ink,

each in turn fed by six small bottles sitting in a rack. As the printer software will still imagine that ink will fly out of each of the six original cartridge chambers, make sure to connect the right color to the right chamber. Now you need to arrange your printer in its permanent place of residence and then organize your inks to sit alongside the right-hand edge of the device. The inks must not be raised higher than the height of the print head or you'll risk ink flooding out of the head when not in use. As stated, all changes you make to accommodate the CIS can be reversed, provided you take care to unlock various pieces of your printer carefully. Ensure that

the device is switched off at the mains and start by releasing the printer head from its resting place. On most Epson printers, a small print head-locking pin can be released by manually adjusting a nearby gear wheel which will enable the head to move freely along the tracking rods. Move the head into the cartridge change position, then remove the cartridge holder lids carefully. Keep these to one side, in case you one day wish to remove the CIS.

Once the lids have been removed, the CIS cartridge can be installed carefully with a little persuasive force. After this, most of your hard work and concentration is complete, except for the final task of sticking the network of ink veins firmly out of the way of moving parts and fixing rubber printer lid stoppers. This allows you to partially close the lid and protect the printer's innards from any atmospheric gremlins. Of course, once you step outside the same brand of printer, ink and paper combination, you'll need to consider color managing your new materials to get the best of them. With your printer software designed to produce finely tuned results from familiar inks and paper, you really need to install an additional color profile that recognizes the innate characteristics of your ink and paper. Both ConeTech and Lyson offer downloadable profile files to match their own various ink and paper products and these can be easily installed into your system in minutes. One of the best advantages of using the CIS is that it effectively gives you the space and resources to really test your materials and save your own personal settings.

Compatibility and best uses

CIS products are designed only to work with certain brands and models of inkjet printer, owing to the adapted printer cartridge. They are widely available for most recent Epson inkjets, some Canon models and fewer still HP printers. As each individual printer is designed to work with a specific ink cartridge, an appropriate CIS must be purchased to match. Indeed, it's interesting to note that these systems are not forward compatible as you upgrade your printer every few years, so your investment needs to be planned carefully.

It is also worth remembering that most contemporary printers are supported with some of the very recent models as yet in development. If you are thinking of upgrading your printer, it is a good idea to keep your old model as a CIS and keep it for running special colors or even monochrome.

With many top quality inkjet printers in the secondhand market, such as Epson 1200 and 1270s, a dedicated monochrome printer is not as extravagant as it might sound. Using two different print units to separate mono output from color will save you time and money spent on cleaning fluids to flush out mono cartridges from your color system. With a dedicated mono printer, you can also establish your own profiles and customize color settings to suit that device.

Not included in the price of most CIS, ink has to be bought as an extra. Despite the high price of branded cartridges, bottled ink is very much more economical to run. Lyson offers a number of different products to support their CIS, including the lightfast Fotonic range and the popular Small Gamut range.

CIS BRANDS TO CONSIDER

Lyson Print Essential
One of the most popular on the market in the UK over the past two years. The pack includes easy to follow instructions and installation tips for converting your printer. This CIS can be disconnected from your printer at any point in the future if you decide to return to standard inksets.

Niagara II
An innovative pre-filled system that reduces the need for vacuuming and fiddly syringes. Useful if you don't feel confident about tackling a tricky installation and troubleshooting inkflow problems.

Pro Ink Evolution
Recently established product that offers a good price for a CIS for older pre-chipped inkjets. A good brand to consider if you are thinking about upgrading your current printer and using your old one with a CIS.

Inkflow from Fotospeed
A new system that offers little resistance to printer heads and lets you keep the lid firmly in place. Useful if you don't want to operate your printer with the inner working visible, or it is prone to accidental touching.

Permaflow
Aimed at the top end of the market for fine printing on art papers and with the latest seven color printers. Like the Lyson, the Permaflow offers top quality and good ink products.

Online printing services

Just like shopping online, you can now order top quality digital prints from an Internet based photo lab, all from the convenience of your desktop PC.

Using online photo labs

If you're a confident surfer and find shopping through a web browser a piece of cake, you can make use of the growing number of online digital printing services. The process works by uploading digital files to an online photo lab website such as Photobox, which prints your images onto conventional photographic paper, then dispatches them back to you by first class post. The system is so simple, speedy and cost effective, you'll never miss a deadline again.

How it works

Your uploaded digital image files are received at the other end by a high capacity server linked to an automated digital mini-lab printer, identical to the machines used in commercial photo labs. Photobox uses the very best quality mini-labs like the Fuji Frontier, which use a fine laser to 'beam' your images onto conventional silver-based color photographic paper. This revolutionary process avoids the use of a traditional enlarging lens, so common mini-lab problems such as print scratches, dust or poor focus never appear on the end result. In fact, the print quality is so high and at such a low cost that the service matches professional lab output at a commercial price.

Working out image resolution

In order to take advantage of the super high print quality, you must save your images with a resolution of 200 ppi, or your prints will have visibly square pixels. Once you're ready to upload your files, go to your Image Size dialog box and check that the Resample button is deselected. Next, set your Document Size resolution to 200 pixels per inch and then the Width and Height will tell you the maximum size your image can be printed out.

File transfer

Many Internet photo labs are global rather than local businesses and as such have built their systems around one of the two common web browsers, Microsoft Internet Explorer or Netscape Communicator. Thus, browser based services are cross platform and will work on both Windows PCs and Apple computers. The act of uploading image files sounds much more complex than it really is and in reality resembles sending an email attachment.

Other service providers use their own specially devised transfer software such as the worldwide ColorMailer lab and their own Photo Service software. The Photo Service program is free and easy to download and, unlike browser based services, offers a useful set of additional preview tools. The ColorMailer Photo Service lets you crop, rotate and place borders around your images and, most usefully, tells you when the print size you've ordered exceeds the resolution of your digital image file.

Compressing your files

The trade-off with online albums is the time you spend connected to the Internet making the transfer. Yet, if you've got a monthly fixed-price Internet connection with unmetered access, then this is less of an issue. Uploading large image files via a slow Internet connection will take a long time, so compressing your images beforehand is a necessity. The temptation to compress your image files for a faster transfer will sacrifice high print quality, so the compression routine should only be undertaken using the visual preview offered by Photoshop and Photoshop Elements' Save for Web command. Most labs will only accept images saved in the compressed JPEG format and Apple users will need to ensure that their files are saved with the all important .jpg three-digit file extension.

Online albums

Internet photo labs also offer a password-protected storage facility so you can create your own online albums. Once uploaded, you can grant access to your friends who can place their own print orders direct with your online lab without bothering you.

Chapter 2
SOFTWARE TOOLS

The latent digital image

Just as the initial exposure made on conventional film is amplified and brought to life by development, so unprocessed digital image files need to undergo a carefully phased editing sequence to reveal their full potential.

Compression facts

Even on the highest specification digital camera, an original image is captured and stored in a state that needs later editing on your home computer. Digital data for high-resolution images is bulky, and, as a consequence, is designed at the point of capture to be as lean as possible. At the very moment of exposure, data is created by the image sensor and this in turn is processed and transported to the camera's memory card. The higher the resolution of the file, the longer this storage event will take.

To enable both detail and color to be recorded with some accuracy, digital camera software designers have created clever ways of reducing data without compromising image quality. This process only works if you, the end user, are skilled and knowledgeable enough to draw out this raw file using image editing software tools. Just as a traditional film negative is interpreted in the darkroom by a master printer, so the raw digital image needs to be drawn out by a carefully plotted software sequence.

If you can visualize your unedited camera file as being like a straight machine print taken from an original negative, you are well on the way to understanding how much more work is needed to turn this latent image into a beautifully hand-crafted equivalent.

File formats

Many column inches have been devoted to establishing the best file format to shoot with. Arguments centre on the comparison between the ubiquitous uncompressed TIFF file format and the variable raw file format options designed by different camera manufacturers. In theory, the TIFF format preserves maximum image quality and links seamlessly with a host of common word processing and desktop publishing applications. Yet when uncompressed data files are created in camera, typically 17Mb and above, each one can take several seconds to process and store. Even on the latest digital SLRs, shooting and saving in this format can place a 10 second 'stop' between different shots, thereby removing any chance of shooting a fast-moving sequence or responding to the unexpected.

With the camera's buffer memory struggling to juggle this huge packet of data and store it safely on the removable memory card, there's simply not enough space to keep shooting. A similar situation is created when shooting in the native raw file format. Saved in a unique format which can only be decoded by the camera's accompanying software, the raw file is opened on your PC and re-saved in a file format of your choice. Not as versatile as the common JPEG or TIFF,

this raw file format can only be opened in Photoshop via a third-party plug-in.

In the face of these two issues, the most efficient way to shoot is by selecting the high quality JPEG option, which is smaller, faster to save and virtually indistinguishable from uncompressed formats. Accepted by all popular image editing applications and suitable for web use too, this is by far the best option. Before processing on your PC, always do a Save As command and change the format to a TIFF, to prevent any further degrading of image quality. The latent image is now ready to develop and enhance.

The Nikon D100 is a sophisticated digital SLR, designed to make color control easier

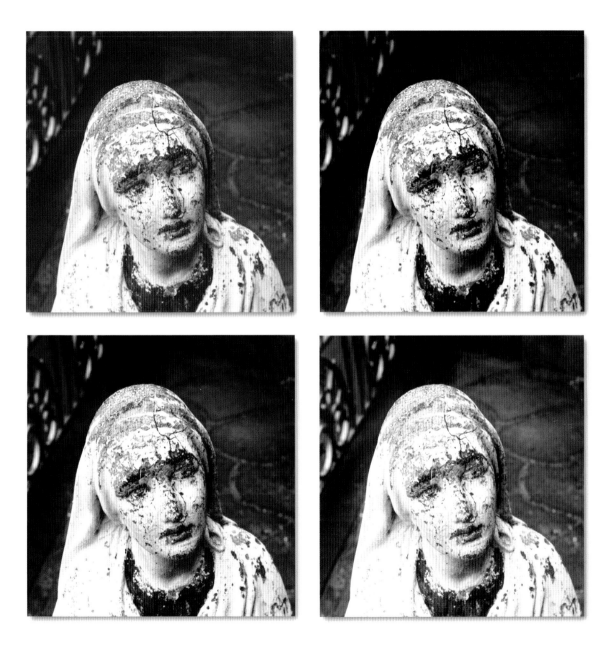

Contrast management

Photoshop offers more than one way of editing image contrast, but which of these offers the most effective results?

What is contrast?

In a digital image, contrast is best described as the balance between the amount of highlight and shadow. Many circumstances influence the amount of contrast in a shooting scene: quality of light, camera exposure, plus all your camera setting options. The primary purpose of image editing is to adjust contrast captured within these limitations and reset it to a visually pleasing result. Rather than thinking of contrast as an impartial and clinical process, judge your image by its own inherent qualities and contrast edit for your target output medium, be it print or onscreen use.

Left unedited, the characteristics of an uncorrected image are weak colors and the absence of bright highlights and rich shadows. The image lacks any kind of visual attraction, especially when shot in very dull, natural lighting.

The Levels dialog box is without doubt one of the core functions of Adobe Photoshop and has remained unaltered through different versions of the program. It is the most sophisticated tool for adjusting the contrast and brightness of your digital photographs. In a digital image, both contrast and brightness are entirely measurable by objective methods, rather than in an arbitrary visual way, and the results can help you solve the

most complex problems. Once measured, this important information is displayed in a histogram graph, which is found within the Levels dialog. Once you've really got to grips with the histogram, you can carefully process and prepare images for perfect print-out and web page use. Indeed, with two scales for changing contrast and brightness, you'll never suffer from muddy prints again.

In a 24-bit image, color is created by the combination of three separate color channels: red, green and blue. Within these channels, color is placed within a 0–255 scale, where zero is black and 255 is the color at its maximum saturation. The histogram shows the spread of pixels across this scale, together with their quantity in each tonal area. All digital images are different and therefore the Levels histogram will be a different shape for each image. Yet for common mistakes such as underexposure and overexposure, or high contrast and low contrast, the typical histogram shape becomes recognizable. Looking inside the dialog, Photoshop offers you tools for remapping pixel brightness from its original state to a new and more appealing end result. Whether your image lacks true blacks and whites or is too murky and muddy, you can easily remap a section of pixels without needing to make a complicated selection.

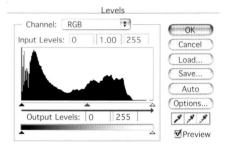

The range of contrast is displayed on the horizontal axis from shadow left to highlight right

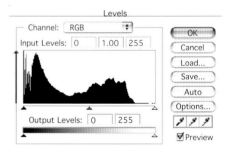

Pixel distribution is displayed on the vertical axis from nil bottom to many top

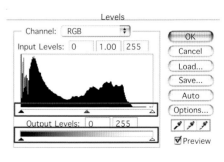

Pixels can be remapped to new values by dragging the triangular sliders

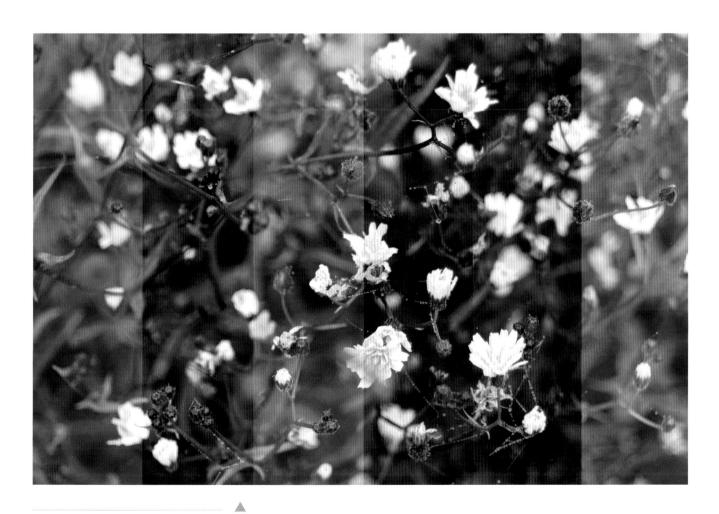

Five different methods of contrast
adjustment applied to an uncorrected image,
from the left: manual Levels correction,
Auto Contrast, Auto Curves, Auto Levels
with Snap Neutral Midtone option, Auto
Levels. The final strip is uncorrected

Hue, saturation and lightness

Photoshop's three color commands can be used to correct a poor exposure. Found in the Hue/Saturation dialog box, they can also be used to add an unexpected twist to your image.

Hue unedited ▲

Hue Master channel set to minus 150 ▲

Hue Master channel set to plus 150 ▲

Hue

Hue is best thought of as another term for color value, such as yellow and red. Left in an unedited state, the Hue values in a digital image will correspond to your original scene. The advantage of a Hue edit is that you can change specific color values, such as turning a yellow lemon red or a blue sky green. Individual colors can be edited in isolation, or all image colors can be shifted simultaneously when working with the Master channel, as shown in the above example.

Saturation

Saturation is another way of describing how vivid your colors are. In an unedited state, the colors in your digital image can look washed out and would benefit from a slight increase in saturation. Individual colors can be saturated or all colors increased together. Too high an increase will create unprintable or out of gamut colors, too low will drain away the intensity altogether. An image with all the color saturation removed will look the same as a greyscale (opposite, above right).

Lightness

Lightness is the least used of the three edits and is a crude way of adding white or black to your image. Not as effective as a Levels or Curves command, it should not be used to correct contrast or brightness imbalances in a poor exposure. The Lightness control should only be used when a pastel or muted low-key color effect is sought. In this example, below right, the image color becomes paler with each increase in lightness until slight holes appear in the highlights.

Saturation set at zero

Saturation set at minus 30

Saturation set at minus 100, fully desaturated

Lightness set at zero

Lightness set at plus 20

Lightness set at plus 50

Defining color settings

Once you've set up your monitor properly, you should spend a little extra time deciding how Photoshop's color management tools will work for you.

Color management seems like a tremendously technical concept for most keen photographers, but it's relatively simple and helps you keep your images in top-class condition. The central problem is that digital image colors rarely look the same when an image file is swapped between different workstations and other hardware devices. To counteract this issue, professional hardware and software have a range of tools to manage the transition without dropping the original image's color values. In your imaging workstation, you can choose to color manage the monitor, all the input devices and all the output devices to maintain color consistency.

Many digital cameras and scanners capture their originals in the universal RGB color mode, but there are several subtle variations such as sRGB, Adobe RGB (1998) and ColorMatch RGB. These mode variations, sometimes referred to as workspaces, have their own unique color palettes, which can alter significantly when converted and viewed in a software application running under a different workspace.

When converted from one workspace to another, such as Adobe RGB (1998) to sRGB, precise pixel color values are mapped to the new palette and can change, usually with a drop in color saturation or a switch from one color value to an unpredictable substitute.

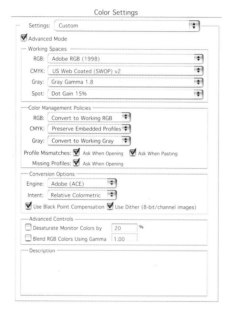

Setting up the color workspace

Some workspaces are less used and have a smaller color palette than others, such as the sRGB space. The best option is to use the largest and most universally recognized workspace, such as the Adobe RGB (1998), which is the best for most accurate color printing and will not cause colors to change. Photoshop can be set to work with Adobe RGB (1998) as its default workspace by making the following command: Photoshop····⫶Color Settings. When the dialog appears, pick the Custom option from the Settings pop-up menu found at the top. Next, click in the RGB pop-up and select Adobe RGB (1998) from the list, as shown above.

Color management policies

To prevent a color conversion disaster, the conversion process can be managed by a tiny piece of software called the Color Management Module or Engine, sometimes referred to as CMM or CME.

Both ColorSync and the Adobe (ACE) are management tools and both are provided with Photoshop, with the latter being the best option. When opening images that have been captured in another workspace, you can configure your CME to deal with the problem in a number of different ways, or policies.

The most common policy is to convert images from a smaller space into your current, larger workspace. The second option is to preserve the integrity of the image's workspace, useful when viewing rather than editing.

To set up these policies, make the same Photoshop····⫶Color Settings command as before, but click the Advanced Mode checkbox, found at the top left of the dialog. Next, choose Convert to Working RGB from the RGB pop-up in the Color Management Policies section.

Conversion to Working RGB can also apply when copying and pasting images from one workspace to the next, rather than operating only when images are opened on your desktop. This option is best employed when dealing with images from a wide variety of sources.

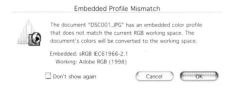

Profile mismatch reminder

While still in the Color Settings dialog, you can also set up Photoshop to prompt you with a visual reminder each time an image file is about to be opened or pasted from another source image. This is most useful when a potentially damaging conversion is about to occur, the Ask When Opening option presents a pop-up panel and gives you the chance to decide what to do before the image is opened. In the Color Management Policies section tick all options, as shown opposite.

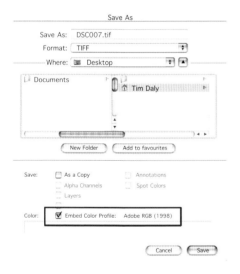

Tagging your documents

Once opened, worked on and ready for saving, the third and final part of the color management workflow can be undertaken. You can choose to save your images with your workspace color profile by doing a File····⟩Save As command. At the bottom of the dialog box, tick the Embed Color profile option, as shown above.

▲

Color settings can also be applied at the point of capture on better digital cameras. Onboard camera software can offer the option of capture in the sRGB mode, shown above top, or in the Adobe RGB (1998) mode, shown above bottom

Scanning principles

It is possible to salvage poor scans with software trickery, but it's far better to have a sound grasp of all the underlying principles to prevent any errors at all.

Scanning your precious originals is no different to developing conventional photographic film, with exceptional levels of concentration required to control image contrast and density.

With such a wide variety of innate differences between black and white and transparency material, excluding personal variations in exposure and density, originals can be a challenge to acquire, even before you get creative. Like over or underdeveloped film, a bad scan will need careful software massaging. In turn, this could stretch and posterize your tonal range and severely limit the later and more interesting creative processes.

As even budget scanners provide exceptional quality image capture, there is a wide range of devices to choose from. Flatbed and film scanners are fitted with a strip of light-sensitive detector cells, which work like the individual cells in an insect's eye. Each electronic eye creates an individual pixel in the resulting digital image, and the more cells your device has, the bigger the print you can make. The number of cells is indicated by the 'resolution' of a scanner, or its ability to capture fine detail. A 600 dpi (dots per inch, but much better remembered as pixels per inch, or ppi) flatbed scanner, for instance, will have 600 individual sensors running across the width of the bed, while a 1200 dpi device has twice as many. With

specifications rising each year, it's reassuring to know that even the lowly 600 ppi flatbed will detect more than enough information from photographic print originals for desktop digital printing. Unlike the state-of-the-art digital cameras, where high resolution comes with a hefty price tag, flatbed scanners offer a much more cost-effective way to get into digital photography.

Color detection

Both film and flatbed scanners, although designed for entirely different purposes, are designed and marketed with different sensing capabilities. Color depth, sometimes referred to as bit-depth, is the first consideration. Just like the range of different colors in an artist's palette, color depth defines the maximum number of colors that can be drawn upon when rendering a scanned image.

If the range of color options is limiting, then less realistic images will result. As a digital artist, you will need to use a minimum color palette loaded with 16.7 million different options (commonly referred to as 24-bit) in order to make a photo-realistic image. This 24-bit palette creates three 8-bit red, green and blue color channels, each with the same range fixed on a 0–255 brightness scale. Yet despite the enormity of the 24-bit palette, many new scanning devices can detect far

more than this. The latest budget scanners can be set to operate with an additional 42-bit super sampling setting that can detect billions of different colors, albeit using slight overkill for most desktop inkjet output. As might be expected, these super sampled images create gigantic file sizes and restrict the user to a limited number of Photoshop commands. With the vast majority of output devices, including monitors, unable to display billions of colors, images will need to be first squeezed back into a 24-bit palette. You'd be unlikely to see any visible difference in a 24-bit end result of a 36-bit or 42-bit scan.

Dynamic range

The phrase 'dynamic range' refers to the scanner's ability to detect detail in areas of highlight and shadow simultaneously. Unlike conventional photographic film types which have their own inherent limits on recording simultaneous detail across a wide range, CCD sensors are much more capable. The process of good scanning involves making an identical copy of your original without losing any highlight and shadow detail in the process. For those experienced darkroom photographers, this is just like duping or making internegs, without any increase in contrast.

Density

In addition to capturing the range of detail across a film or print original, the inherent density of an original needs consideration. Density has become a desktop term taken from both the professional lab and the pre-press bureau world. It essentially describes the range of difference between the most dense area (shadow) and the least dense area (highlight) on both reflective photographic originals, or prints, and transparent originals, or trannies.

The most dense area of an original is called the Dmax and the least dense is called the Dmin. In practice, the measurement of a dynamic range is arrived at by subtracting the Dmin from the Dmax. A typical transparency material has a Dmax of 3.3 and a Dmin of 0.3, resulting in a density range of 3.0D. Print materials have a much more compressed density range, set somewhere between 2.0D and 1.7D.

The inherent difficulties in capturing a faithful scan from a color transparency centre on the lack of light transmitted through the densest shadow areas, which can prove too much for a budget film scanner with a density range under 3.0D. Better or repro-quality scanners, which have a dynamic range of 3.0D and over, can deal with these difficult tasks and also other hidden gems such as overexposed or overdeveloped black and white negs, ultra dense lith film and even oddities like infra-red.

Density is much less of a problem if you only shoot and scan color negatives or chromogenic XP1/2, as these sensitive materials at maximum overexposure are less dense than others.

Resolution

Resolution in this instance refers to the number of pixels the scanner can create from an inch of picture information. Flatbeds are described by two measurements, for example 600 x 1200 ppi, or width x length. With many devices now producing up to 2400 pixels per inch, searching for good quality is much less of an issue than with film scanners.

With film originals being inherently smaller than prints, film scanner sensors are built with much higher resolutions. Typically starting at around 2400 ppi and increasing to around 4000 ppi (the former creates 20-30Mb and the latter a gargantuan 70Mb+ of information), higher price devices enable you to output on a larger scale. When scanning medium format film it's important to check that the maximum scanner resolution is not halved or interpolated through the range.

Optical and interpolated

Just to confuse things further, scanner resolution is often quoted in two distinctly different values: optical and interpolated. The optical value gives a true hardware specification, i.e. the actual number of sensor cells fitted in your scanner; an interpolated value, however, indicates how much your image can be enlarged by software trickery. Remember that with an interpolated image, extra pixels are squeezed in between the original ones, with their color value being an estimated average of the adjoining pixels' color. These interpolated images by their very nature can never have the same sharpness or quality as optical scans, so even if your scanner can 'capture' at 13,000 ppi, images will be bigger, but not as sharp. Indeed, interpolated images compromise sharpness unless viewed from a distance, like a poster print.

Scanning methods

Making a good quality scan involves using your scanning software tools to the full, leaving little corrective editing to do on the captured image.

At the heart of the scanning operation is the scanning software. All scanners are bundled with two types of software: either a small stand-alone application or a Photoshop plug-in. Stand-alone software can be operated independently of an imaging application like Photoshop and will take up much less of your computer's memory resources. For repeated use or batch scanning, this will allow a faster transferral of images to your PC.

The other alternative is the plug-in, enabling you to operate the device and the same scanning application from within a compatible application like PaintShop Pro or Adobe Photoshop. Once the scanner's software plug-in has been installed in the application's plug-in folder, the device can be found via the File⋯⟩Import⋯⟩Plug-in software command. With a plug-in, once an image is captured, the scanning software closes automatically and you are left in Photoshop to manipulate your image instantly. Another variation on the plug-in comes through the universal TWAIN. TWAIN, somewhat bizarrely, stands for Toolkit Without An Interesting Name and it essentially works like a software 'travel plug' by allowing many different third-party devices to interface with Photoshop and any other TWAIN-compliant application. With the latest imaging applications increasingly hungry for memory resources, many users advocate using the basic Photoshop LE together with their scanner plug-ins, to minimize memory use and to speed up capture and simple processing.

Scanning techniques

In film-based photography the capture of different subject matter demands the use of specific materials and techniques to achieve the best quality and scanning is no exception. As a general principle, greater control of contrast and brightness can be exercised in your professional imaging application, so excessive fiddling in the scanner software dialog is unnecessary. The sole aim at this stage is to avoid increasing contrast, dropping detail or generating any image artefacts. The controls that can cause such mishaps are the Auto exposure command, the highlight/shadow sliders and the various filters, such as Sharpening, that work on the fly and generate a bad scan with pre-set commands that can't be removed. Just like developing black and white negative in a low contrast developer, the aim is to produce a subtly toned original that can undergo further creative interpretation later on.

Quality of originals

Color photographic prints from commercial mini-labs are very rarely pin-sharp and do not display the sensitivity of a hand-made print, so any scan you make from this kind of original will merely echo and magnify these limitations. You can pull much more data of better quality out of a 35mm film original than you can from its 6 x 4 proof print. With a small original, any future enlargement will be hampered by interpolation, but a scan at maximum optical resolution from film will give you all the options you need. It's important to remember that a typical photographic print does not have much more than 200 dots per inch of original detail anyway, so a higher resolution scan won't find any more hidden detail.

Paper surfaces

Another potential problem is found when scanning photographic prints made on non-glossy surfaces. Stipple or lustre paper prints will retain the same fixed pattern after scanning and will exhibit a noticeable lack of sharpness compared to glossy print media. There's little way around this and only slight changes can be made with the Unsharp Mask filter. A much better option is to scan the original film, but if this proves impossible, then the quality can be slightly improved by scanning at maximum resolution followed by a resampling downwards. Similar problems can be encountered when scanning fine exhibition-quality papers like Ektalure.

Enlarge and reduce function

Think of this like the enlarge/reduce
button on a photocopier. If you scan a
6 x 4 photo print, at 100% and 200 ppi,
then output it to an inkjet without
resampling, you'll end up with a 6 x 4
inkjet print. Enlarging only works well
when the size of increase falls below the
optical maximum and when there is
enough detail present in the original. The
same process can be completed using
the Resample command in most imaging
applications' Image Size dialog box.

Scaling factors

For output to magazine or books, the
lithographic printing process demands
an additional set of rules. The general
principle is to set the input resolution
at double the screen frequency or
ruling to be used on the press. Most
color litho work is output at 133 or 150
lines per inch, so a digital image scanned
at 300 ppi will suffice for most situations
and can even be reduced to 266 ppi
without much loss of quality. If you
prepare your images with two pixels
available for each printed dot, less repro
problems will occur.

Contrast management

Both budget and professional scanners
offer a range of different tools for
adjusting contrast during the scanning
process. The Auto Contrast correction
setting offers a prompt way of re-aligning
white and black points, but this may
come at a price. Magic Match settings
work in a similar vein by optimizing the
scan for a particular branded printer, but
this does not take into account your local
settings and media. Where available, the
best option is to use standard Levels
tools within the scanning software.

*A color RGB scan made with two different contrast
adjusting tools. The top picture was created using
manual Levels, the bottom with Auto Contrast*

Advanced scanning software

Most scanners can be operated with additional third party software for the better control of contrast, color and color management. Silverfast is a product well worth considering.

If you've ever felt held back by the childlike interface of your scanning software, then it could be time to try out something a bit more grown up. Silverfast is now a well-established third party software tool for making top quality scans from both film and flatbed scanners. Made by Lasersoft Imaging, the product is cleverly designed to fill the enormous gap in the quality of current scanning software that offers such a limited range of tools for a discerning user. It's available to work with over two hundred different scanners from a range of well known manufacturers such as Umax, Microtek and Epson, it can be operated as a stand-alone application or a Photoshop plug-in and is TWAIN compliant too.

Just as the complex Adobe Photoshop towers above simpler consumer software applications, so Silverfast offers a professional level of control at every stage of the capture process. Set to push your scanner to the very limits of its hardware capabilities, it's well worth the extra investment.

Overview

Perhaps the most immediate difference in the operation of this kind of software, ignoring the advanced technical tricks for a minute or two, is the flexibility in both preview window and preview resolution. With basic scanning software you are frequently restricted to a tiny preview image window, which presents your scanning subject at such a small and crude size that it's impossible to judge the complexities of the task ahead. Indeed, although many software tools offer you the chance to increase the preview window size, it won't be at any higher resolution, leaving a large-scale pixel mosaic instead.

Just as you can customize the Photoshop desktop into a comfortable and conducive working environment, so Silverfast can be set up exactly to fit in with your demands. Once the software is launched, the preview window expands to fit the vertical dimensions of your monitor and can be flipped over to a horizontal format to make landscape image scanning easier.

To ensure you are viewing the all important prescan at top quality, you can opt to create a x8 high resolution preview so everything is pin-sharp and displayed in a large color palette. The principle behind Silverfast is that all processing and adjustments are made on the prescan beforehand, so you can get a good view of the likely results before the full scan itself. With each and every adjustment you select, such as an unsharp mask filter or dust and scratch removal, an extra amount of processing time is added after the scan is completed and before the image appears on your desktop.

Silverfast's larger than average preview window

Basic capture modes

Like all scanning software, the choice of how much data to create from your scan is placed in the most prominent position. Depending on the hardware capabilities of your scanning device, Silverfast has a range of useful options for capturing in 42-bit RGB and 14-bit greyscale modes but, crucially, translating them back into standard 24-bit and 8-bit at the end of the process. For those who've had the

The scanner control window

Individual color curves can be adjusted before the scan takes place and are vital tools for rescuing originals with unusual contrast

the useful Scan Pilot, a clever console-like device for guiding you step by step through the correct sequence of prescan, applying enhancements and then deciding on the final output. The third and most interesting palette is a mini-desktop densitometer. With a wide range of color correction and enhancement tools, the densitometer offers a reassuring way of monitoring the amount of change and also any color gamut warnings. Preview images can be measured in all common modes such as greyscale, RGB, CMYK and Lab, and the densitometer displays the original, unprocessed values alongside your intended enhancements, so you can make a judgement on the quantity of change. Just like Photoshop's Info dialog box, the densitometer will allow you to make pin-point readings from individual image pixels. When a problem color for the current color space is detected, a simple triangle appears in the dialog box to give you advance warning.

Filters

Where lesser software falls down is in the provision of filters for on-the-fly sharpening, color correction and the removal of physical defects. Like the clever Digital Ice tools ROC, GEM and ICE, Silverfast is bundled with its own versions of ICE which work very well. The standard unsharp mask filter is provided with a familiar dialog box holding slider controls, so you can choose exactly how much to apply, instead of choosing a low, medium or high sharpening option in lesser scanning software. For those ancient originals that are full of physical defects, the SRD filter offers control over dust and scratch removal. Great for applying to hairy transparencies, the filter can be used across the entire image or just within a selection area. The filter essentially works by applying a slight blur which uses

misfortune to create gigantic 48-bit scans which then render Photoshop virtually speechless, this auto conversion offers the best of all scenarios. Top quality monochrome scans can be pulled out of exhibition prints using the 14-bit mode without any visible increase in shadows or highlight areas.

Desktop palettes

Both the preview window and control panel are separated, so you can drag the technical settings away from your image to concentrate on the task. By default, all the main controls are offered in a single palette, which is designed to show the most important parameters in a simple and jargon-free manner. The second smaller palette is

surrounding colors to infill black or white marks for a very convincing result. For faded color originals, the ACR filter, otherwise known as Adaptive Color Restoration, helps to restore low contrast color to its former glory. Finally, and most useful for photographers shooting with both film or digital cameras, the GANE filter can be used for minimizing grain and eliminating noise. All filtering occurs after the final scan is undertaken and will increase the delay before your image appears on the desktop.

Scanner calibration

Just like color calibrating your monitor and printer, scanners can be set to work within a tightly controlled color environment.

If you currently operate your scanner as a basic capture device accepting the shortfall in both color accuracy and contrast, you'll be spending plenty of time correcting your scans in Photoshop. While this can indeed be an acceptable way of working for those inclined to avoid the complexities of calibration and color management, a gradual decrease in image quality will occur. Most scanners used in this way are like most printers and will offer slight changes to an original's color and contrast levels within a certain correctable tolerance, but if a little time is spent in advance calibrating your device, less time will be wasted making adjustments and contemplating the finer arts of color correction.

Color management

In contrast to basic scanning, you can elect to use your scanner within a tightly controlled color managed system. Just like the advanced color management tools found in the latest version of Adobe Photoshop, you can operate your desktop scanning device with its own dedicated color profile and color management software. Most scanners aimed at the amateur market are used without any color management whatsoever and produce raw images which can suffer the consequences of conversion once opened in Photoshop. In a normal color managed

workflow, there are three issues you need to contend with: the idiosyncrasies of the capture device, the output device, and how an image is converted between the two. In principle, each input and output device has its own inherent limitations when describing color. In a professional workflow, each piece of hardware is first tested to determine the way in which it describes color in a process calibration. Once tested, the results are saved and stored in a data file which is used each time an image is captured or displayed.

Scanner calibration

Silverfast software comes with its own useful scanner calibration tools which are activated from both plug-in and stand-alone versions of the application. In order for the process to work, you must first obtain a standard IT8 color reference target, made by Kodak, Agfa or Lasersoft. These targets are pre-printed on print material for reflective scanning or pre-exposed onto transparency material for transmissive scanning. The purpose of the IT8 target is to act as a neutral color reference chart which is matched against a color original during the calibration sequence. Together with the chart is an all-important text file which holds the reference data for all the individual color and tonal patches. You can't complete the calibration without this reference file, but

An IT8 color reference target

they are freely available for download from the target manufacturer's own website. IT8 targets made by Lasersoft have their own corresponding data files already on the Silverfast application CD. The process is very simple: after an initial prescan is made, the calibration manager is called into play. Once you've dragged the marquee tightly around the recommended areas of the target print, the next step is to identify the reference file. By default, Silverfast automatically looks within its own subfolders held within the Photoshop Plug-in folder and if the data file is in a different location, no calibration will occur. After dragging the file into the correct folder, the prescan and calibration process will render an accurate color scan. Like using Adobe Gamma to calibrate your monitor, this simple calibration exercise needs to be done only once. With each

future scan, color information is compared to the reference file and then modified, but this is an invisible activity occurring in the background.

Color profiles

Just as many top quality digital cameras can be set to tag image files with a color profile such as sRGB or Adobe (1998), so Silverfast allows you to save your scans with a specific profile. Profiles are nothing more than an overcomplicated description of a color palette, defined by the number of colors that can be reproduced. While most digital cameras capture and save in the smaller sRGB color space, which is Photoshop's own default space, much better results are gained via the bigger Adobe RGB (1998). If you've never altered the color settings since acquiring your versions of Photoshop 6 or 7, then it is worth changing them now. Under Edit⸱⸱⸱⸱▸Color Settings, make sure the top RGB drop-down menu in the Working Spaces section is set to Adobe RGB (1998). With Silverfast, scans can be saved with the Adobe RGB (1998) profile embedded within the file, providing a seamless conversion when opened in Photoshop later on.

Weblink

To check out whether Silverfast can run with your scanner, visit the Lasersoft website on www.silverfast.com

Top right: ▶
A calibrated scan

Bottom right:
An uncalibrated scan

Chapter 3

MANAGING COLOR

Calibrating your monitor

When faced with a murky print and an unrecognizable color cast, can you really be sure where the fault lies if you haven't corrected your monitor to start with?

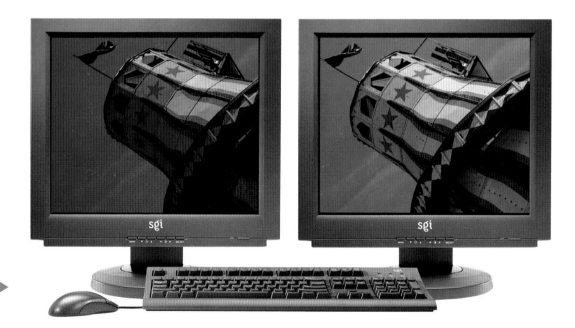

Monitor calibration helps to create a reliable color environment

There's only one way to get your workstation color calibrated and that involves setting up your monitor properly before doing anything else. Yet before digging deep into software solutions, you can start off with some sensible housekeeping. To ensure that you are not psychologically influenced by strong desktop colors, graphics or patterns, set your desktop to a neutral grey. Despite the attraction of wild colors, your ability to detect color casts in your image window can be strangely influenced by the surrounding background. Warm desktop colors such as red will make your image appear warmer, even though no actual change has taken place. Just as a colored window mount can affect your perception of a framed photograph, a busy desktop can be an unwanted distraction.

In addition to the basic button-driven color and contrast controls found on your display, your PC will also have a software tool for much more accurate measuring.

Thankfully, no scientific knowledge is required on your part, as monitor calibration software works by guiding you through a simple step-by-step sequence. Setting neutral color balance, contrast and the all-important tonal mid-point called gamma along the way, these careful measurements are saved, stored and re-used each time you launch your imaging application. By keeping your screen display consistent, they take you one step closer to eliminating doubt when judging

your prints. With a neutral monitor set at the right gamma, your prints will never emerge darker or lighter than you'd hoped. The age-old difference between PC and Mac displays are now much less of an issue, thanks to invisible converters found within Photoshop and other applications, but you will still need to set your workstation up beforehand.

Despite all the variations of calibration software, all systems are based on the same four tools for measuring screen color: contrast and brightness, gamma and white point. Both Windows XP and Mac OSX provide their own built-in monitor calibration software, but a good alternative is Adobe Gamma. Bundled free with Adobe Photoshop, this works by prompting you to make a visual measurement rather than using add-on hardware calibrating devices and is an excellent place to start.

Regardless of the software product used, the process is identical and kicks off by loading the profile which corresponds most closely to the actual monitor you are testing. After visually adjusting the four different parameters, the final measurement must be saved with a different name to your starting profile. Once finished, this will be referenced by your imaging applications that can work with color profiles and, on most up to date PCs and all Macs, your operating system too. A good policy is to repeat your monitor calibration every three months or so and include the date in the new profile file name. Default system settings for monitor gamma are fixed at 1.8 for Apple computers and 2.2 for Windows-based PCs. Once saved by your system software, the monitor profiles are matched by your imaging application, so your image files retain their original brightness range when opened.

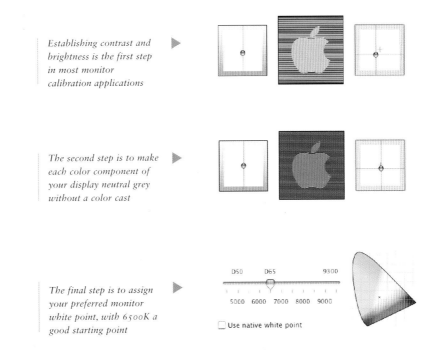

Establishing contrast and brightness is the first step in most monitor calibration applications ▷

The second step is to make each color component of your display neutral grey without a color cast ▷

The final step is to assign your preferred monitor white point, with 6500K a good starting point ▷

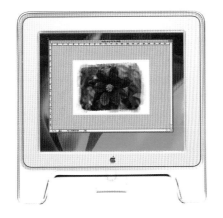

Despite the attraction of a multi-colored moving desktop pattern, this feature of your PCs operating system can really hinder accurate color judgements. Bright colors next to your image can suggest casts that are not really present in the file.

A much better option is to set your desktop pattern to a neutral midtone grey. As demonstrated above, your total attention now falls on the colors within the image itself, rather than being distracted by brighter or more vivid colors elsewhere.

Daylight color temperature

There's very little color consistency in natural daylight, but if you know what to expect and when, you can always make allowances.

Local influencers

Many location portraits are shot under very variable lighting conditions. The above example was shot under the canopy of several green leafy trees. Unlike artificial light sources, daylight is infinitely variable in terms of its intensity, direction, contrast and, in this image, color.

When an object is placed in a strongly colored environment, its own color is altered, absorbing and reflecting the unusual local conditions. In this example, the tree canopy acts like a giant green light filter, effectively transforming all objects that lie beneath. As a result, the colorless daylight is altered, which plays havoc with flesh tones and anything white.

On location, fashion photographers often hold giant translucent white umbrellas over their models, kept well out of shot, to both soften and filter unwanted colors out of natural daylight.

Cloud cover

The presence of the sun can make a dramatic difference not just to the contrast of an image, but also to its color temperature. In this example, cloud cover was preventing the full direct sun from illuminating the landscape. The results are low contrast with an increased blue color.

Many conventional photographic films were designed to be oversensitive to the blue end of the spectrum, which is the predominant color in daylight, but this resulted in washed out and weak color images.

Images shot under cloud cover will always look less vivid than you expect, but this is easily corrected in your image editing application. The dominant blue will compromise other colors in the image, resulting in weak greens or cyan skies. This is easily corrected by adding extra yellow to the entire image until the dominant blue disappears.

Seasonal differences

The time of year will affect the color and strength of daylight. In the summer months, daylight is plentiful and will usually offer high levels of contrast with the sun high in the sky. The best time for shooting delicate colors while avoiding the problems of excessive contrast is during the morning.

For location photography in the winter months, the absence of daylight for prolonged periods removes the luxury of choice. Yet despite the lack of intense levels of light, the lower position of the sun in the sky can provide raking shadows.

The important part natural light plays in the creation of your images should not be removed by clumsy image editing. Be wary of applying auto corrections, as your seasonal colors could be removed in a flash, leaving you with neutral but essentially characterless results.

Sunlight

Although direct sunlight will reveal colors at their most vivid, there are plenty of potential pitfalls to deal with. While alluring and seemingly ideal, the effects of full sunlight never become apparent until image files are printed out. As this example shows, full sunlight produces rich colors, but also creates deep pockets of black shadow and very bright highlights. Left uncorrected, an image like this will be tricky to print on a desktop device, as both shadow and highlight extremes will tend to spread.

Faced with these shooting circumstances, it's essential to take a range of different exposures, erring towards overexposure if in doubt. By allowing additional light onto your sensor, your black shadow areas will effectively lighten up and show more detail, but this must not be at the expense of losing the detail in your highlights. The best results from this type of image are gained by lightening the midtones and reducing the overall image contrast with your Levels controls.

Morning

A firm favourite with landscape and travel photographers, the early morning shoot offers every opportunity to capture accurate color and maximum detail. For those working in a hot climate, this time of day will often be the only effective period to shoot, as excessive light contrast places shadows and highlights outside the dynamic range of your camera sensor. Especially useful for shooting architectural details away from the distorting effects of raking sunlight, early morning light is delicate with a cooler color temperature.

Images shot during this period will appear slightly blue or colder than those shot at midday, but this is easily corrected in your image editing application. Correction in camera is also possible by using a warm-up filter such as a Kodak 85A (or equivalent), or by making a custom white balance setting. Correction in your image editor is also possible by applying a slight orange color balance edit with equal amounts of yellow and red.

Evening

Shooting at the last possible time slot in the day offers an ideal opportunity to create stunning visual effects. Known by photographers as the magic light, this short 20-minute period occurs when the sun illuminates the landscape in golden light. Accompanying this effect will be high contrast and the deepest of all shadow areas, resulting in silhouette shapes that will not reveal detail and cannot be recovered in your editing application. Image colors during this time of day will be warmer and redder than those captured at noon. For a range of different color intensities, try experimenting with a slight underexposure in camera.

Digital cameras are less suited to shooting in very low light conditions, which create unwanted effects, or noise, when used at a high ISO. The best results come from using long exposures with the help of a tripod, rather than hand holding your camera with a high ISO setting to compensate for low light levels.

Resolution principles

It can be difficult to gauge just exactly how much data you need to make a photo-realistic print. But megabytes, pixel dimensions and megapixels all give you the same information: the maximum enlargement size.

Digital camera resolution

Astonishingly, pixels are not created with a fixed size. Nonetheless, the three RGB ingredients in color recipe can recreate the same colored pixel, be it an inch square or a metre square.

You, the user, are responsible for setting the pixel size to match the intended output. Using Photoshop's Image Size dialog box, pixel size can be set at 72 per inch or 200 per inch. The number of pixels in the image remains the same, but they are made physically bigger or smaller.

At an inch square, pixels resemble tiles from a giant mosaic, giving a poor photographic illusion. The smaller your pixels are, the more invisible they become and the more realistic the print.

All digital cameras create images with pixels set at 72 per inch by default. By setting them at the smaller 200 dpi, your print-out will be physically smaller but higher quality.

Many basic image editing packages that accompany digital cameras offer an option for converting raw camera files as they are opened on your desktop PC. Image resolution can also be set to your own nominated size in the Preferences dialog in Adobe Photoshop, so all new documents can be created at 200 dpi for inkjet output or 300 dpi for litho end use.

Low resolution in camera

A low resolution image captured by a digital camera at the smallest pixel dimension, typically 640 x 480, is not suitable for print-out and will become blurred if enlarged in the Image Size dialog box.

A low resolution print-out

If your printer is set to Draft, Plain paper or 360 dpi, the image will appear speckled, as fewer than normal ink drops are sprayed onto the paper.

High resolution in camera

A high resolution image captured by a digital camera at the highest pixel dimension, such as 3000 x 2000, is fit for high quality print-out on a desktop inkjet.

A high resolution print-out

A high quality inkjet is produced by setting your image file to 200 ppi and your printer at 1440, 2880 or 5660. This avoids visible dots, white areas or clumping of printer ink.

Scanner resolution

The term resolution is just another way of describing potential image quality. Like the variously sized megapixel sensors found in digital cameras, flatbeds are also sold on the basis of their resolution. Unlike digital cameras, scanner quality is not described in megapixels or in pixel dimensions, but by the ability to capture pixels across one linear inch. In other words, a 600 pixel per inch or ppi scanner will create a 3600 x 2400 digital image from a 6 x 4 inch photo print. Even budget 1200 ppi scanners create more data than is really needed, and anything over 2400 ppi is overkill for desktop photo printing. Pound for pound, a flatbed scanner generates more digital data than a professional digital SLR and is still the most cost-effective route into digital photography.

Printer resolution

Most printers can be operated in lower-quality or draft mode for making rough prints or layout proofs which keeps down your consumable costs. A printer resolution of 360 dpi will drop less dots on the receiving paper even if your image is a high resolution file. Resolutions of 1440, 2880 or 5660 dpi produce the best photo quality, but expect printing to take longer and more ink to be used. Never select the High Speed setting for printing high quality output, as your results will be compromised. When testing your media, try each different paper at a range of high resolution dpi, as you may not be able to see any difference between 5660 and 2880. The drop in image quality is often imperceptible at 2880, and you will save time and make ink economies.

A low resolution scan

A low resolution scan doesn't have enough pixels to describe curved, complex shapes or detail and will result in fuzzy or staircased edges.

A high resolution scan

Like a high resolution image created by a digital camera, the high res scan captures all visible details in a print original. This example was scanned at 300 ppi.

RESOLUTION FAQs

What are pixels?

Pixels are the tiny building blocks of a digital photo which are stacked together in a chessboard-like grid, sometimes called a bitmap. Pixels are mostly square in shape and the more you have, the bigger and better the quality of the print-out. At a small size, such as 200 pixels per inch, they are invisible to the naked eye. The telltale blocks become apparent on your print when set at the larger 72 pixels per inch.

How are they colored?

Pixels are colored by three ingredients: red, green and blue. Each ingredient has 256 variations. When combined together they can form up to 16.7 million different colors, more than enough to mimic the look of a real photo print.

What are megapixels?

Digital cameras are graded according to how many pixels they can create. A megapixel is made up of a million pixels, so a 2.1 megapixel camera can make an image containing 2.1 million individual pixels. If you prefer to think in height x width, then an 1800 x 1200 pixel image equals 2.1 million pixels.

How is an image created in computer code?

Digital images are stored in the binary number code and create a lot of data. The color of each individual pixel is described by a string of 24 numbers and a high res image containing many millions of pixels creates a gigantic amount of data.

Resizing images

Digital files offer you the chance to scale your images up or down in size without compromising final print quality, if resizing is carried out correctly.

The physical dimensions of a digital image are not exactly straightforward and not as easy to visualize as a 6 x 4 glossy photographic print. Digital images are variously and confusingly described as high resolution or low resolution, 2, 3 or more megapixels and even talked about in straightforward megabyte terms.

Yet the size of a digital image will have an enormous bearing on the print size and quality you can reasonably expect to produce.

Leaving aside all those issues, the best way of describing a digital image is by its pixel dimensions, i.e. the horizontal and vertical count of the image when first scanned or captured with a digital camera. An image of 1800 x 1200 pixels is the kind of size produced by a mid-price digital compact. By default, in line with all other digital cameras, this is packaged with a fixed 72 pixels per inch or ppi resolution.

This resolution setting purely describes the size of an individual pixel and can be changed, most importantly, without altering the file size and pixel dimensions, using the Image Size dialog box. Actual pixel size can be set at 300, 200 or 72 ppi for commercial repro, inkjet and web outputs respectively, but this will alter the physical size of the final image. At 300 ppi, an 1800 x 1200 image will make a 6 x 4 inch print; at 200 ppi, the same file will make a 7.5 x 6 inch print.

Preparing the right resolution for output should be the very first task you do in the Image Size control, but most crucially it needs to be done with the Resample box unchecked. Left switched on, this option will either introduce new pixels to your image to make it larger at the expense of sharpness, or throw away original pixels and make it smaller and lower quality.

Interpolation

Resampling, downsampling and upsampling are all terms used to describe interpolation, the process of adding or subtracting pixels from your image. The color of new pixels is based on the average color of the surrounding pixels, but with a compromise in sharpness. Smaller parts of your image transformed to fit in a montage project are also interpolated using the default interpolation mode as set in the Preferences.

Using the Unsharp Mask filter

After enlarging or downsampling your original image, some sharpness will have been lost along the way. This can easily be re-established using the Unsharp Mask Filter just prior to print-out. For very drastic reductions from a high resolution file to a tiny web thumbnail, USM should be applied after each reduction if several individual steps are made.

RESIZING FOR WEB PAGE USE

Downsampling
Reducing a digital image is called downsampling and involves throwing away original pixels to make the dimensions smaller for web only use. As with enlarging, images are best sharpened at the end with the Unsharp Mask Filter.

Step 1: Resample
Start by changing the Resolution to 72 pixels per inch, as this matches the resolution of most monitor screens. Ensure that the Resample Image option is switched off at this point.

Step 2: Think in pixels
Rather than referring to the centimetre or inch scale used for determining print size, use the Pixel Dimensions read out, as monitor resolution is based on pixels. Remember that even at 600 pixels wide, an image will look enormous on a web page and be slow to download. Set your size and press OK.

Step 3: Check the size
Confirm the exact size your new image will appear on the web by viewing it at 100% or by choosing View----⟩Actual Size. Don't be disheartened if the quality is poor at 200%, as it will never be seen at this magnification by others.

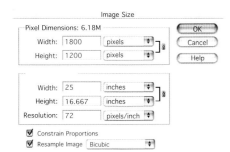

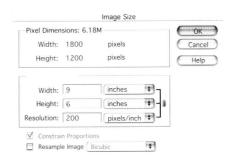

Prepare for print step 1 ⋯⋗

Open your image for the first time

After uploading from your digital camera or scanner, open the image in Photoshop and choose Image⋯⋗Resize⋯⋗Image Size. Here, you are faced with a dialog box that confirms the 1800 x 1200 pixel dimensions in the top panel, with the current file size shown underneath.

Prepare for print step 2 ⋯⋗

Change the resolution

Turn the Resample Image option off and in the document size area of the dialog box, change the Resolution from 72 to 200 pixels/inch. Notice that the Pixel Dimensions have remained unchanged, but that the document size has shrunk because you've made your pixels smaller so they're less visible on your print-out.

Prepare for print step 3

Check the print size

Click OK and return to your image window. To confirm your new print size, go to File⋯⋗Print Preview and check that your image sits within the margins of the currently selected paper size and that it fits the portrait or landscape orientation correctly.

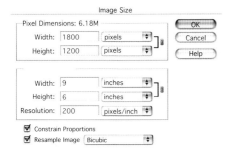

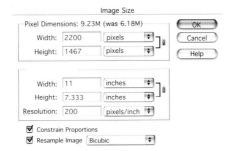

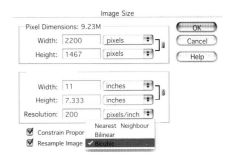

Enlarging your print step 1 ⋯⋗

Add new pixels

Enlarging a digital image means adding new and invented pixels to the original ones. After completing the first two steps as above, stay in the Image Size dialog, but check the Resample Image option before starting the enlargement process. Ensure the Constrain Proportions option is selected, or your enlargement will be distorted. New pixel colors are estimated by the interpolation method chosen.

Enlarging your print step 2 ⋯⋗

Set the new print size

Type in the desired size in the document size text box and watch how both file size and Pixel Dimensions increase. Be realistic at this stage: enlarge your image by no more than 25% to maintain the highest quality. Bigger enlargements will look softer and lose color saturation, although this is less of an issue if you intend to produce poster size prints which will be viewed from a distance of several feet.

Enlarging your print step 3

Choose the Interpolation method

Finally, choose the method of introducing new pixels from the pop-up menu found to the right of the Resample Image option. Choose Bicubic for best results from photographic images and Nearest Neighbour for hard-edged graphic images, then press OK. There's no advantage to scaling up a print in several smaller steps as this is unlikely to improve the overall appearance of the image.

Chapter 4
PROOFING, PREVIEW AND PREDICTION

Color gamut

If your print-outs never look as good as they do on the monitor, it's probably because you are trying to achieve the impossible.

A computer monitor displays color in a fundamentally different way to the way a printer outputs colored ink on paper. The monitor transmits richly saturated colored light via RGB phosphors, but print-outs reflect less vivid colors. Each station in the capture, processing and output of a digital photo has its own unique range of colors called a gamut, which is better imagined as a palette.

When an image is transferred from one stage to another, colors can reproduce with less saturation than expected or even translate into a different color altogether. If you are frequently disappointed by the difference between print-out and display, it's because you are trying to exceed the range, or gamut, of your ink and paper combination. Yet by using Photoshop's Gamut Warning functions, you can make a better prediction of potential mistakes before you waste paper and ink.

Photoshop allows you to increase the color saturation of an image very simply, but this will never translate to your print-outs with the same intensity.

These overambitious colors are detected by switching on the Gamut Warning option, found in the View menu. Once switched on, the Gamut Warning option is left on for the duration of your work in progress and works by turning grey all the colors unlikely to print as they appear on screen. This grey is not embedded in your image file, but acts purely as a marker and doesn't print out.

As you work steadily throughout your project, the Gamut Warning will show up only when you try and stretch color saturation or use special color palettes such as the Pantone ranges, which frequently can't be reproduced by inkjet printers.

It's a much better idea to have the Gamut Warning selected from the outset, because smaller problems can be dealt with on the spot rather than trying to tackle an insurmountable problem at the end of your work.

In addition to color balancing your print and calibrating your paper to cope with the limitations of your chosen ink and printer software, it's essential that you edit within the gamut of your device. There's nothing more disheartening than trying to match vivid colors on screen with a disappointing print-out.

Choosing safer colors from the Picker

If you want to work with printer-safe colors at the end of a brush, you can use another of Photoshop's Gamut functions, found in the Color Picker dialog box.

When searching for colors that will print as you see them onscreen, make a normal selection by clicking into the color box. If a tiny red warning triangle appears, shown above at the top right hand corner of the current color box, this means your selection is out of gamut.

This function is very useful if you start to edit using solid colors and will ensure that your chosen hues are well within the range and don't fall out of gamut as your project takes shape.

If you do choose an unsafe color, you can easily change this into the nearest printable value by clicking on the tiny triangle itself. This command shoots your selection circle into the nearest equivalent position, leaving you with the best alternative value.

Step 1: Switch the warning on

Open your image and, before making any color balance corrections or color enhancements, turn on the Gamut Warning, found under the View menu. Any problem colors will be shown as grey.

In this example, the bright reds and yellows of the flower are too intense in the original image (below, top), printing out much duller than expected (below, bottom).

The method of correcting gamut problems using the Replace Color command works by reducing the intensity of dominant colors to a saturation value that lies within the printer's range. For very difficult gamut problems, it may also be necessary to slightly alter the hue to maintain current saturation levels. In this example, the red poppy was changed to a warmer orange hue to enable high levels of saturation to remain in the print-out.

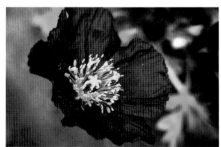

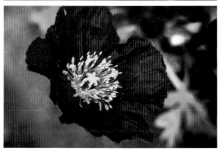

Step 2: One color at a time

Open the Replace Color dialog and move it to one side of your desktop, so you can see the tagged colors. Click on the Selection option in the preview window as shown. Use the dropper tool and click into the grey area of your image and then push the Fuzziness slider until all out of gamut colors are selected. It's best to tackle one hue at a time, so exclude other vivid colors by selecting them with the minus dropper tool.

Step 3: Fine tuning

Next, move the Saturation slider to the left and watch the grey marker color disappear. If you haven't managed to remove all the grey, return to the Replace Color dialog and repeat the process, but this time sampling a different grey area. To remove the marker from the yellows, Hue, Saturation and Lightness sliders were moved slightly until the warning disappeared. Once removed, what you see is what will print.

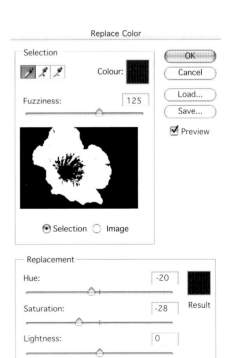

CMYK Proof mode

If you are preparing image files for lithographic reproduction, you'll need to package your files in the CMYK image mode. By using the Proof mode, you can still have all the benefits of RGB.

The downside of CMYK

If you need to work in the CMYK mode, you'll notice that many of Photoshop's functions and features become unavailable. Yet there's a simple way around editing files for CMYK output: simply use the CMYK Proof mode.

In this way of working, your image file remains in the RGB color space throughout, but is constantly previewed as the likely results of final CMYK conversion.

Document sizes remain unaltered and you have all the access to Photoshop's editing tools from creatively processing your image files.

CMYK files are drawn from a much smaller color palette compared to RGB and this frequently causes disappointing repro results. Most vivid colors do not reproduce well, especially in the blue/purple range. With the Proof function in use, your image won't display a color or saturation value that can't be matched in the CMYK color mode.

Setting up the Proof option

In the View menu, choose Proof Setup, followed by the Working CMYK option. Come out of the menu and then select Proof Color from the drop-down menu. Your image file will now display the terms RGB/CMYK on the top window bar to denote you are now in CMYK Proof Mode.

This original image was edited in the RGB mode before later conversion to CMYK below. Many bright colors did not translate across the two spaces ▶

Edited in the RGB mode but with the CMYK preview switched on, the likely results were much more apparent during the work in progress. ▶

Using Print Preview

In early image editing software applications, predicting the paper orientation, image layout and border size was mostly guess work. Now the Print Preview function enables you to take control.

Drag and drop positioning

Perhaps the most creative tool found in the Print Preview dialog box is the ability to manually drag your image to a chosen position on your print paper. With many photographers employing the use of a DTP application purely to create off-centre print compositions, this is a very useful feature.

To use, first make sure that the Center Image option is deselected, then select the Show Bounding box option. Next, position your cursor inside the preview panel and click drag your image into the desired position. Remember the entire image file will be repositioned, so you can't position a caption in a different area.

Scale to Fit Media

This is a useful option if you need to output prints in a hurry and do not require the best quality. It works by adjusting the pixel dimensions of your image to fit your chosen paper size and orientation.

Before starting, make sure your image is lying in the same portrait or landscape orientation as your paper. In the Print Preview dialog, select the Scale to Fit Media option and watch how your image shrinks or enlarges to fit the paper.

The process uses the current resampling method that you have specified in the Preferences and will reduce image quality, particularly when low resolution files are enlarged too much.

Borders with the Bounding Box

The Bounding Box tool allows you to control the exact size of border around your image. If you can't work out how your pixel dimensions relate to the overall print paper size, then you can easily determine the border size by selecting the Bounding Box option.

Start by deselecting the Scale to Fit Media, then position your cursor over any of the four handles that have appeared around your image. Drag outwards to enlarge or inwards to reduce without distorting the proportions of your image. This process also employs resampling and could lower the quality of your output.

Soft-proofing paper and inks

Photoshop offers a very useful feature to help you predict the way your image will print on your chosen media by previewing the result on your screen.

Deep inside the inner workings of Photoshop is an effective tool for predicting how your print will look on different paper stocks.

In the complex and costly world of commercial printing, taking risks can be expensive. So if printers could see into the future and predict exactly how work in progress will print out, they would save a lot of time and aggravation.

Exactly the same issue needs addressing when making inkjet prints on your desktop system: just how do you prepare an image if Photoshop doesn't know how a sheet of Epson paper will respond to your file? Well, surprisingly Photoshop does know and can display the likely result as a soft-proof preview.

Soft-proofing essentials

If different input and output devices can have their own dedicated color profiles, there's no reason why a particular paper and ink combination can't follow suit. At the time of installation Photoshop is loaded with a huge number of profiles which correspond to input, display and output devices. Photoshop also builds up a library of new profiles each time you install a new printer or new scanning software. Supplied by the printer manufacturer to help pre-visualize the likely results of printing on their

papers, paper profiles are well worth investigating. These profiles can be called into play when you want to use a particular type of print paper and, most importantly, predict the likely outcome. Just as the Gamut Warning predicts non-printing colors (p. 58), the soft-proof preview mimics the likely look of the printed version on your monitor. Like all color management features, this function is only worth using if you have already established color settings and calibrated your monitor. Once established, you can save your settings so they become a permanent menu feature.

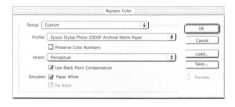

Setting up the soft-proof

Go to View⋯⋙Proof Setup⋯⋙Custom and check the Preview button so you can see the change as it happens. In the Profile drop-down, click and hold until you can pick the color profile that matches your intended image destination. The profiles you will have on your machine will depend on the version(s) of printer software you've installed. If you carry this command out without an open image file, it will become your default soft-proof.

Defining the settings

After choosing the profile, return to the dialog box and deselect the Preserve Color Numbers box. Next, from the Intent drop-down menu, choose the Perceptual option as your rendering intent. A rendering intent dictates how your colors are mapped from one color space to another and the Perceptual option offers the least visible change. Finally, choose Black Point Compensation and Simulate Paper White, to get an indication of the difference between your monitor white point and the base white color of your printing paper.

Comparing the results

The original image is displayed in this instance without the soft-proof option selected and shows bright colors that are unlikely to print on this special paper. To view your soft-proof, type Cntrl/Command + Y to turn it on and the same to turn it off.

Selecting the soft-proof view

With the View⋯Proof Colors function selected, the soft-proof image is now shown and displays a slight loss of saturation, and a duller white point. Despite the disappointing change, the soft-proof is a much better simulation of the final result than the uncorrected monitor display. You can tell if you are viewing a soft-proof as its name will be displayed on the top of your image window next to the image mode following a forward slash.

Practical uses

For those keen on using pigment inks together with archival cotton media, the soft-proof option is a very valuable way of working. With such a dramatic change evident between monitor and final print-out, the soft-proof function can help avoid wasting paper and expensive inks and help you process your files to better suit the chosen material.

Weblink

Many good quality paper manufacturers such as Lyson provide profiles to go with their materials. These can also be used within Photoshop to create a unique soft-proof for each paper and ink combination. Got to www.lyson.com to download their free paper profiles.

Top: A screenshot of an RGB image without the Proof Set-up option selected

Bottom: The same image proofed to a pigment ink/archival matte paper combination

Making test strips

You'll never achieve a perfect print on the first try. Conserve your expensive print consumables by making smaller test prints before committing to a full-size output.

Choosing the test area

The purpose of making a test strip is to first identify a small area of your image that represents the full range of highlight and shadows. In the above example, the chosen central area contained the entire range of tones from the brightest highlights to the densest shadows. The size of the final selection shape fell well within the size of the chosen print paper.

Start the process by using the Rectangular Marquee tool to drag a shape around the chosen area. Ensure that the tool has a feather value of zero, or the printer software won't respond to the command.

Selecting paper

The advantage of printing out a smaller selection area is that you can opt to use much smaller sheets of paper instead of wasting an entire sheet on a small test area.

Yet, just like an experienced darkroom photographer, it's essential that you maintain consistent media and printer software settings throughout. There's no point in using one kind of paper for the test and another for the final print, as the print results will be very different. Always ensure that your paper stocks remain the same throughout the process and you'll be guaranteed consistent results.

Before committing to testing your image file for the first time, make sure the printer software settings chosen are the best for your chosen paper media.

With purpose-made glossy media, you'll find that very little adjustments will be necessary after the test emerges, but with more porous watercolor media, your initial tests will always look darker than expected with muddy colors.

The problems increase when you opt to use branded media that is not supported by your dedicated printer software and inksets. This kind of media will need a little more trial use and testing to produce better results, but your successful settings can be saved easily.

Organizing the printer software

After selecting your chosen area, go to File···⟩Print with Preview and watch the dialog box appear, as shown above. Ensure that the image file fully fits the size of your chosen paper media without using the Scale to Fit Media option. When any resampling method is chosen to print a smaller test, both color and tonal balance will change dramatically from test to full size print, so this is best avoided.

Next, click on the Print Selected Area option to tell the printer that your test selection is the only part of the image you want to send for output. The example shown above describes a typical print dialog box as found in many different Epson printer software drivers, but most other brands also offer this option.

Complete the command by checking the Center Image box, as this will ensure your test prints out in the middle of the sheet. Once output, it's a good idea to annotate the test, to make future comparison easier.

 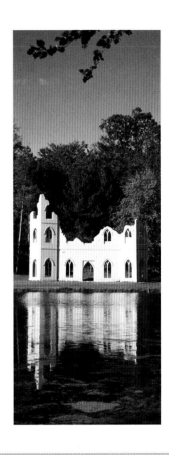

Test 1: Too dark

Often the first result out of your printer will be a test strip which is far too dark. Although set with richly saturated colors and deep shadows, this kind of print will hide textures and details that you want to reveal.

With a dark print, the excess ink will create a warmer than expected result and compromise any color balancing commands you may have made previously. Return to the Levels dialog and move your Midtone slider 15 steps towards Shadow.

Test 2: Too light

If you experience this kind of result, then your print is too light. With most of the atmosphere removed from the scene, a light print will display washed out highlights together with desaturated colors.

To correct, return to the Levels dialog and move your Midtone slider 15 steps towards Highlight. If this is a second test print, use your History palette to return to your starting point rather than apply a third correction to avoid artefacts.

Test 3: Just right

In an ideal print, there's a good mix of shadow and highlight, plenty of detail where appropriate and some rich colors. On a subject with many contrasts as in this example, the final print will always be a compromise. If in doubt, always err on the light side as this allows you to create additional emphasis without applying the same rate of change across the entire image. To do this, use the Burn or Dodge tools or apply a Levels command within a feathered selection.

Chapter 5

ENHANCING COLOR

Using your lens properly

Some of the most significant problems with color photography can stem from a poorly prepared lens, or an ill chosen lens gadget.

For spectacle wearers the idea of compromising on a cheaper pair that didn't offer the same kind of clarity is unthinkable. Yet, in choosing a camera kit, photographers often make poor judgements when it comes to deciding on optical equipment. Although modern digital sensors on SLR cameras are as yet unable to resolve line for line all the detail produced by a top quality lens, there's no reason to opt for a cheaper third party equivalent. The very best optics are essential for getting the best color, contrast and visible detail in your raw files.

Lenses are designed and manufactured with a special invisible coating that improves contrast and color saturation, often appearing green or pink when held against the light. Just like a pair of filthy spectacles, a dirty lens will not allow light to pass through to the sensor without blurring and losing quality.

Watch the light

Photography's golden rule is to keep the light source behind you, so you avoid lens flare. Flare is caused by excessive light entering the lens and bouncing around, creating washed out streaks which are impossible to remove in your image editing application. A good lens hood will stop this happening.

Cleaning your sensor

With repeated changes of lens, allowing dust and dirt to access the camera body, your image sensor can frequently become dirty. The dirt shows up as simple hairline shapes, occurring in the same place in the frame on different image files. For most users this is not a serious issue, unless you are shooting studio shots with a pure white background. Most camera manufacturers provide in-depth instructions on cleaning your sensor, but if in doubt, return your camera body for a service.

Maximum image quality

Despite the knowledge that tiny aperture values such as f16 and f22 provide the greatest depth of field, the question of image quality is a different issue. A lens performs best in the middle of its aperture range, typically f8 or thereabouts, producing the sharpest detail it is capable of. The poorest performances occur at both ends of the aperture scale.

Lens attachments and converters

Although seemingly convenient, gadgets for increasing your focal length or helping you to get closer will inevitably diminish your final results unless you opt for top quality products from Canon or Nikon.

A wide angle lens needs a very specific kind of hood to avoid vignetting and excess flare

Prime lenses

The very best image quality is achieved when using prime lenses, as shown above, compared to those with a fixed focal length rather than a jack-of-all-trades zoom.

If convenience is important, opt for short range zooms, as those with excessive ranges will be difficult to use and will not produce the same kind of quality as prime or short range zooms.

A good short range lens is a 18–35mm or 24–80mm. You'll pay more for those models which maintain a fixed maximum aperture throughout the entire range.

Use a skylight filter

Consider protecting your SLR lenses with a multicoated Skylight or UV filter. Purchased as an optional extra to fit your lens, they do a good job of preventing the delicate coatings on the surface of your lens becoming scratched or dirty. If you do damage your filter, it's cheap to replace.

Skylight filters also provide a slight improvement in color saturation. The colorless filter does not impact on your exposure levels or interrupt autofocus mechanisms.

Always opt for a quality filter to add to your lens. The best ones are multicoated and from a reputable manufacturer such as Hoya or Lee.

Skylight and UV filters can also be added to a removable filter holder to assist in landscape photography, although check for vignetting (black corners on your files) if two filters are used together.

Use the recommended lens hood

All photographic lenses are designed to work in conjunction with a specific model of lens hood, or shade. Despite this, few manufacturers sell new lenses with the recommended part.

Instead, photographers are asked to consider this as an optional extra, which it most certainly is not. You will only need to buy the right hood once. The right hood for the right lens is designed to prevent the maximum amount of extraneous light from entering the lens itself and affecting the exposure. With a proper hood, your colors will be at their most vivid and contrast will be optimized too.

Despite the attraction of cheaper, off the shelf hoods, these will never produce the same results and can often cause vignetting.

Keep your lens clean

Common results from a dirty lens range from a complete loss of contrast to pale color streaks across your image, with a loss of sharpness too.

Camera lenses should never be touched under any circumstances, but if they are, it's important to remove the greasy marks using only specially designed lens-cleaning tissues. First remove any dust or sand, using a soft sable paintbrush, or blower brush, then gently rub the lens in a circular motion until the smear is removed. Always keep a pack of tissues in your camera bag.

Raw file processing

Once shot and transferred to your PC, a simple four-stage processing sequence can help to improve the shortcomings of your raw file.

Most digital cameras use an anti-aliasing filter in front of the image sensor to prevent the effects of aliasing, that curious situation when square pixels try to describe curved shapes. More visible when shooting in low resolution modes, jaggy edges are also very evident when inbuilt contrast controls are set at too high a value. The jagged edges known as staircasing can really give the game away and identify your print as coming from a digital source. The anti-aliasing filter works by applying a slight softening of the image to minimize the visual effects of aliasing.

Although straightforward, the edit sequence should not be applied through a pre-set automated action, as each image will need its own unique treatment. While digital sensors are much more capable of recording simultaneous detail in both black shadows and white highlights, raw files can appear a little on the flat side. Unlike traditional film, CCD sensors are able to record a very subtle tonal range even in extreme lighting conditions, keeping detail at both ends of the range. Yet raw images lack contrast with highlights and shadows reproducing as paler shades of grey, which in turn can add a flatter appearance to the image.

The first step in the four-stage

sequence is to set both highlights and shadows using the Levels controls. Used to re-assign highlight and shadow points in a raw image, this first edit will create an instant gain in contrast.

As a result of this edit, any color casts apparent in this image will now become a lot more visible. In a dark underexposed raw file, images can look warmer than the original scene, but this can disappear after a good Levels edit. If a color balance correction was applied before a Levels edit, then you are more likely to introduce another cast than remove one. Once highlights and shadows are set, adjust the 'exposure' of your image by moving the midtone Levels slider to make it darker or lighter. After this, you are now ready to make the second edit in the sequence.

Achieving faithful color reproduction is a never-ending task for graphics professionals and is a process made much more complex by the introduction of an enormous variety of different cameras, scanners and printers working to different standards. Color casts make an image look dull and muddy and prevent the bright colors you'd expected from singing at the tops of their voices. Yet casts are easily removed as long as you know the fundamental principles of the color wheel. In all color reproduction there are six colors broken into three opposite pairings: red and cyan, magenta and green, blue

and yellow. When color casts are present, they are caused by an exaggerated amount of one of these six colors. Casts can be simply removed by increasing the value of the opposite color until they disappear altogether. There's no mystery to the process, just a straightforward edit.

Where to spot color casts

The easiest place to spot color casts is in a neutral color area of your image, preferably a grey midtone. Strong white highlights and deep black shadows will never show a cast in its true colors, nor will a patch of fully saturated color, but if you are lucky enough to have a midtone grey in your image, you'll get a much better idea about the extent of your problem. If no such grey occurs, base your corrections on a skin-tone area.

Natural light changes color throughout the day, starting off blue and ending up red. Color is perhaps the hardest aspect of an image to judge if you are not used to working in a consistent color environment, but the process can be made much easier if Photoshop's Variations dialog box is used instead. Producing a simple ring-around of alternative colored versions, the dialog allows you the luxury of comparative side by side judgement.

Start by setting the correction amounts to the Midtones only and see how one of the versions will look best. Once casts are removed and color is corrected, other image colors return to full saturation and are not subdued.

Using Color Balance controls

Much more advanced control can be achieved using the less visual Color Balance dialog. The success of the command relies entirely on your ability to spot which color is causing the cast and remembering the solution from your color theory. Corrections are made by increasing the amount of the opposite color to the cast, with the change becoming instantly visible in the image window. For removing casts from artificial light, apply your corrections with the Highlight option selected. If your digital camera images have persistent color casts, check that the White Balance setting hasn't been switched to artificial light by mistake.

Color correction need not be treated as an exact science based on perfect neutrality, but should be based on your own creative interpretation. In general, images look best when produced slightly on the warm side, just like shooting transparency with a slight warm-up filter. If your raw image was shot in anything other than sunny conditions, the result will be a little cold with a decidedly blue cast. Correct this by adding an extra 5-10 yellow in the Color Balance dialog.

Saturation

Once your image is cast-free or warmed up, you are ready to make the third edit to your file. In the compressed JPEG file format, color values are reduced to help maximize data savings, squeezing more information into a smaller file size. Any color casts present in the original scene will be reproduced faithfully, albeit in a slightly weaker form. A greater range of color means more data, so raw files are always desaturated and bland. To correct this, rich colors can easily be put back or made even more vivid than they were in the original by using the Hue/Saturation slider as the third stage in the editing sequence. Every image benefits from a slight increase in saturation values, using the tools found in the Hue/Saturation dialog box. An extra 10 units can turn a weary and watery image into a real eye-catcher. Before the fourth and final stage, ensure that you have completed all your other creative edits, such as burning in and other handcrafted edits to create better emphasis in your image.

How sharpening works

The fourth and final step is sharpening. The magical sharpening tools can be used to tweak an image into fine focus, but can't be used to correct camera shake or badly focused work. Sharpening is nothing more than increasing the level of contrast between edge pixels. In a soft-focused image, colors are muted at the edges of shapes, but in a pin-sharp example colors are more widespread and have inherently more contrast. All images benefit from software sharpening, applied as the final stage just before the printing. Applied too early in an edit, artefacts caused by sharpening will become magnified and

Even a slight increase in color saturation can transform a raw color file

destroy image quality. All images should be sharpened after resizing in either direction, as interpolation causes an inevitable loss of original image detail. Photoshop is supplied with four sharpening filters: Sharpen, Sharpen More, Sharpen Edges and the Unsharp Mask, all of which can be applied to the image overall or to selected areas.

The Unsharp Mask tool

Found under the Filter⸱⸱⸱⟩Sharpen⸱⸱⸱⟩Unsharp Mask command, the USM has three controls: Amount, Radius and Threshold. Amount describes the extent of the change of pixel color contrast. The Radius slider is used to determine the number of affected pixels surrounding an edge pixel, with low values defining a narrow band and high values creating a thicker edge. The final Threshold modifier is used to determine how different a pixel must be from its neighbours before sharpening is applied. At a zero Threshold, all pixels in an image are sharpened, resulting in a noisy and unsatisfactory image. Set at a higher value, less visible defects will occur overall. As a general guide, set your filter to Amount 100, Radius 1 and Threshold 1. If this looks too much, reduce your Amount to 50.

Top shows an unedited or raw version of the file. Bottom shows the fully corrected end result

Color balance essentials

The successful removal of color casts depends on a thorough understanding of the basic principles and a keen eye when things go wrong.

Even the best photographers end up with color casts on their prints, but the real secret is knowing how to correct these problems without destroying image quality.

Muddy colors are created when too much ink is dropped onto the printing paper with one or more colors appearing to dominate the print. With an overall yellow, red, cyan or magenta cast, the remaining image colors are compromised and dulled down considerably. The first step in controlling this event is to ensure that image brightness is set at the correct level. By changing the brightness of the image with the Levels controls, printed colors will start to look more saturated and free from casts. Set too dark, print colors will look more yellow than normal; set too light, print colors will look too blue.

When printing for the first time, the natural tendency is to produce prints that are darker than they should be, perhaps as an unconscious response to the washed out photo lab prints that we are accustomed to. A good starting point is to identify the darkest area of your image onscreen, then make sure this still remains the darkest part of your print. If any other parts of the print turn out as dark, then you need to lighten up your file and reprint. With a perfectly judged print, you can now add emphasis effects such as burning in or holding back.

Casts created on location

As seen on p.50, the color of natural daylight is far from consistent and depends on location and time of day. Photographs taken in the early morning will inevitably appear more bluish than the same subject shot under a midday sun, looking 'colder' and perhaps less appealing.

Towards the end of the day, natural light becomes redder and produces warmer and more inviting results. Your choice of location can also have a dramatic effect on color reproduction; even an innocuous canopy of trees will cast a grim green color across any portrait sitter unlucky enough to be positioned underneath.

Casts created by artificial lighting

Light produced by an artificial source is not drawn from the same even spread of the color spectrum as natural light. Instead, it is produced in a narrow range such as green or orange.

Domestic light bulbs are usually based on a tungsten filament and produce deep red-orange results. In contrast, fluorescent tubes produce a heavy green cast which will instantly suck the life out of any color photograph. Casts created by artificial sources may need to be removed in the highlight areas of the image as well as the midtones.

Casts created during printing

Despite the care and attention you take during shooting, combining ink and printing paper from different manufacturers can produce color casts. Very few inkjet papers will work well without some prior tweaking, with the cheapest adding a persistent color cast to all of your images. If it still appears on your print, even though you've corrected your image onscreen, try using the Color Controls in your printer software.

Using your printer software

If all else fails and your prints still emerge with an unexpected cast, try changing the color adjustment settings in your printer software. This will apply another correction in addition to anything set in your imaging application, and once perfected can be saved, stored and applied to any future images printed using the same paper and ink combination.

Filling-in

Inkjet printers are prone to filling in the near-shadow areas of an image unless careful adjustments are made before printing. Printer ink values are ranged on a 0–100% scale and can display little tonal separation above 90%. Dark and atmospheric images need careful preparation; if in doubt it's a good idea to prepare a lighter image, or brighten your shadows with Curves.

Photoshop's Variations dialog

Go to Image⟶Adjustments⟶Variations. Here you will be presented with a panel showing your image placed in the centre of a color ringaround, as shown on the right. Six versions encircle your central original, each with the same amount of change applied. Green lies opposite magenta on the horizontal, while yellow opposes blue and cyan faces red.

The Variations dialog works by allowing you to simply click any of the surrounding variations that look better than your central original value. It's rare to create an image which has more than one color cast, except for images shot under mixed lighting.

You can click more than one within the edit and if you go too far, you can always return to your original value without overcooking your image. For those who are new to digital photography, the Variations dialog offers the easiest way to color balance your image without resorting to an auto command.

For this illustration, a sample graphic has been produced, above, that shows a clean neutral grey rectangle lying underneath each of the six main colors.

When loaded into the Variations dialog, this graphic is placed centrally, as shown above.

Color casts are far easier to view in neutral grey areas of your image rather than in areas of fully saturated colors. Examine each of the grey rectangles in the ringaround, as shown right, observing that even a slight amount of additional color has a profound effect on color balance. In addition to this, observe how different casts affect the saturation of colors. In the yellow variation, blue is reproduced less saturated than expected.

Best settings to use

The Variations dialog offers you the chance to preview potential color corrections in many different strengths. In all but extreme circumstances, set your amount to the second notch away from Fine, so your previews look delicate rather than coarse. Select the Midtone option for removing casts in daylight illuminated images. For images shot under artificial light, make an initial correction under the Highlight setting, then switch to Midtone to complete the color balance corrrection.

How to see color casts

Color imbalance is difficult to detect if you are new to color printing, and removing the wrong colors can make matters worse.

Most machine-made conventional photo prints offer washed out colors and less impact than we could create ourselves, but knowing how to produce top quality results depends first and foremost on color control.

Despite the accuracy of a fully calibrated monitor and a color managed workflow, detecting rogue colors presents a perceptual issue rather than a technical one. Warm prints, those characterized by the addition of more red and yellow than usual, often look far more attractive than colder prints, which contain more blue or cyan.

Most photographers are on the receiving end of the color print process, rarely spending time in a conventional color darkroom but relying on commercial processing services instead. Divorced from this hands-on connection with color management, many of us are conditioned to accept substandard prints produced by budget laboratories.

The standard machine print is typically produced by a single exposure, in reality a compromise setting that doesn't allow shadow details to emerge or enhance any smaller areas of the image. You'll never achieve top quality printing if your process is based on machine-style global image correction.

The working environment

If you have the luxury of a permanently housed digital darkroom in your home, then you need to make sure that it's set up correctly. All image editing work can be affected adversely by the influence of extraneous light and color, so the first task in designing the ideal workspace is to achieve consistent levels of illumination.

Most domestic rooms have light-producing windows which provide varying intensities and colors of light throughout the day. Windows are best covered in a blackout blind so that an even level of lighting is produced by your artificial sources. Aim for a level of room illumination that is lower than the brightness produced by your monitor, or you'll struggle to judge tone and color onscreen.

No saturated colors should be used to paint the walls of your workshop and bright white should be avoided too. The best option is to paint your walls in a matt neutral grey color with 60% reflectance. This color conforms to the Munsell 8 grey, as a reference for your local paint supplier.

Always avoid placing your monitor where reflections from windows or light sources will appear and avoid placing any kind of brightly colored object in your working environment, including your own clothing.

Viewing conditions

The best way to start off your color balancing process is to ensure that you are viewing your prints in a color controlled environment. Viewing prints under domestic tungsten lightbulbs will not offer accurate conditions as the color temperature of the source is variable.

A much better option is to invest in a form of color calibrated lighting that conforms to a common international standard.

The D50 lighting standard is a universal guide for those products that adhere to a neutral color temperature of 5000K. This standard is gaining increasing acceptance in the professional environment as the most acceptable source under which to view prints. With a color that appears neutral to the human eye, the D50 standard is an ideal starting point.

Depending on your budget, the process is as simple as replacing the fluorescent tubes in your workspace for D50 compliant tubes, or investing in a specially calibrated viewing booth. Built like a box with one side open and illuminated from above, the viewing booth creates a completely controlled lighting environment which remains unaffected by ambient light. By placing your prints inside the box, you can be assured of the cleanest of light environments.

Delicate casts are best observed in the neutral color areas of an image ▶

Working with white

Just like shooting snow scenes with an automatic camera, creating the appearance of true white can be a challenge.

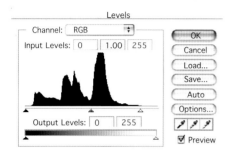

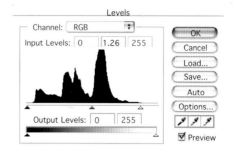

Understanding the histogram

No camera meter can ever produce an automatic exposure that creates clean white subjects. In fact, most meters are designed to avoid this conclusion at all costs. Any subjects that contain a large area of white will always be captured in a muddy grey tone. This is because the camera meter tries to balance out the lights and darks of the scene into a compromise exposure.

After opening your image in your editing application, go straight to the Levels histogram to effect change. The three illustrations above show a simple editing sequence that converts the whites in the image opposite from muddy to clean, without losing any detail in the highlights.

Before processing, the histogram resembles the example above left, with the tonal distribution of pixels lying mostly in the mid to shadow zones. There are no noticeable pixels that have a near white value, but this is easily solved in the next step.

Moving the highlights

Start the process by working in the Input Levels area of your dialog box, rather than the Output Levels area, which controls the start and end points of your tonal range.

Click on the tiny white triangle found on the baseline of the black mountain histogram shape. By default, the highlight triangle is set at the far right corner. Your task is to drag this white triangle to the left until it sits underneath the first point of the sloping foot. This black shape denotes the lightest pixels in the image, which are currently grey and which will be changed to white by this edit.

Look at your image and click Preview on and off to get a before and after comparison. If the image still appears muddy, then slide the grey midtone triangle to the left, before clicking OK. This will have the effect of lightening the midtones in the image without making the highlights or shadows brighter and upsetting the tonal range. The image is now corrected.

The final histogram

Once OK has been pressed, re-open your Levels dialog and notice that the histogram shape has been stretched sideways to describe an image with a rich highlight area. This example shows only a slight Levels correction which permits future editing without posterization. Extreme stretching will result in tonal gaps and will effectively prevent future change.

Using Brightness/Contrast

Although seemingly the ideal command to use for this task, never use the Brightness/Contrast control as it applies the same rate of change to each and every pixel in your image. This will result in holes appearing in both shadow and highlight areas.

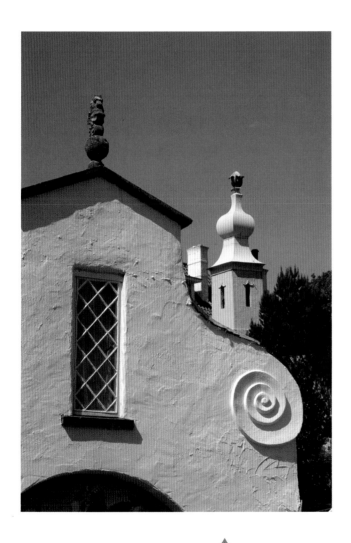

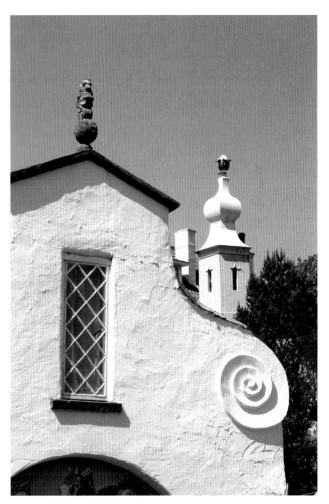

The unprocessed image file is shown above left. Above right shows the same image after a Levels white point adjustment

Color and Adjustment layers

Designed to offer you maximum flexibility without restricting future editing or image quality, the Adjustment layer function is well worth investigating.

Imagine being able to 'float' a creative command over your image without committing to its settings or worrying about losing it in the History palette. Adjustment layers allow you to work in an entirely flexible manner and, unlike normal layers, do not contain pixels but only settings.

Most of Photoshop's critical commands, as found under the Image⋯→Adjustment menu, are also available as Adjustment layers and can be introduced to your image with ease. Levels, Curves and Color Balance commands can all be applied to your image and appear in their familiar dialog box state once actioned.

Once applied to the image, the Adjustment layer appears in your Layers Palette with the name of the command. After making an edit and quitting the Adjustment layer, you can simply return to the command at any time in the future and pick up where you left off.

The state of the dialog box is saved every time, so you're never in danger of overediting your image if you decide to change your command at a later stage. Sliders, Curves and numerical text boxes remain unchanged by your last set of commands and give you the ultimate in flexibility and choice. Lying in the stacking order like normal layers, Adjustment layers will apply themselves to the layers sitting underneath, but those above will remain unaffected. For precise application to a smaller area of a layer, Adjustment layers

▲

This image was created using a Channel Mixer Adjustment layer. After changing the color of the individual flower heads, holes were cut into the Adjustment layer to reveal a combination of background layer and Channel Mixer layer in one

can also be applied through masks or within previously selected areas, the latter being a very effective way of colorizing a single picture element.

Strangely, despite not being constructed from pixels, Adjustment layers can be partially removed by using the eraser tool set with brush properties. If you can imagine cutting holes into a command applied over an entire layer, then you're well on the way to understanding the unique

applications of these creative commands. Best of all, and unlike using the History palette, Photoshop's Adjustment layers can be saved and stored in the PSD file format, so you can really leave your image file open to creative interpretation at any time.

Adjustment layers don't add a significant amount to your image file's data size, so they are a very efficient tool to use. Indeed, they are the best way to apply creative edits to your image for maximum flexibility.

Enhancing with Photo Filter

A new feature of Photoshop is the Photo Filter control, designed to mimic the kind of color correction offered by conventional camera lens filters.

Photographic lens filters work by letting through certain wavelengths of light while barring others. Much used by photographers shooting with the direct positive transparency film medium, lens filters such as the Kodak 81 work by turning a sunless scene into a warm and attractive end result. In the latest version of Photoshop, the new Photo Filter dialog offers a similar kind of intervention that can be applied after taking a shot.

Ensure that you have corrected your Levels before using the Photo Filters, as they will have little effect on images that are too dark or too light. Go to Image⋯⋯>Adjustments⋯⋯>Photo Filters and choose the Filter Type. To warm up a cold image try the weaker 81 or stronger 85 option. To cool down a warm image try using the weaker 80 or the stronger 82. Both 85 and 82 are ideal for correcting white balance errors made at the moment of shooting.

A Warming Filter 81 was applied to the image below left, converting it into a more visually attractive end result.

Chapter 6

CHANGING COLOR

---> Dull to vivid

---> Shade to sunlight

---> Changing individual colors

---> Distressed color

---> Using the Channel Mixer

---> Inverting color

---> 3D color

Dull to vivid

Adjustment layers offer an ideal method for increasing the contrast of your image colors with the maximum flexibility.

Starting point

The best way to make dull colors vivid is to apply corrections to specific parts, or selections, of your image via Adjustment layers. Start by selecting the different parts of your image using the easiest tool available.

In this example, the magnetic lasso tool was used to select the sky area. Once created, a Curves Adjustment layer was applied, followed by a Color Balance Adjustment layer. The selection was then inverted to select the wooden house. A final Levels Adjustment layer was then applied.

Step 2

Before refining any of the Adjustment layers, your Layers palette should resemble the example below. When applied to a selection, an Adjustment layer will create a mask icon within your Layers palette, as shown, meaning the effect will only apply to the black area. The white area remains unedited.

Step 3

Adjust your Levels layer as below.

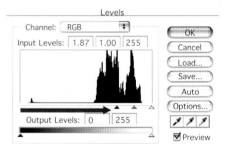

Step 4

Then adjust your Curves layer.

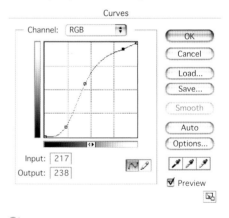

Step 5

Finally, adjust your Color Balance layer as below.

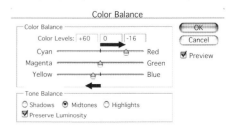

The corrected image

Shade to sunlight

Remove dull lighting and stray sunlight patches with a simple Curves edit, designed to increase both contrast and color saturation.

Starting point

Shooting in the shade can offer an ideal environment for avoiding excessive contrast or squinting, but this can be at the expense of warm colors.

The above example shows an awkward image to process where highlights and shadows are not easy shapes to select and correct.

In these circumstances, a Curves correction is the best way of indentifying and enhancing different tonal areas of the image with maximum control, especially where patches of stray sunlight have disrupted the composition.

Step 1

Open the Curves palette and drag it away from your image's window so you can see the effects of your edit. Ensure that your palette looks like the example below, where shadows are set in the bottom left hand corner of the square.

On the diagonal Curve line, click three points down with your cursor: one in the centre plus one at each side. These original positions are shown by tiny pink squares.

Now correct your image by moving the original points to create the new curve shape below. Your image will become brighter in the midtones and also gain contrast in the highlights.

This correction has a similar effect to using the fill-flash technique in a camera, where poor contrast is raised to produce better colors and less shadow.

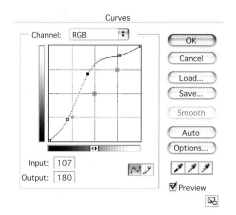

Step 2

Using the Variations dialog box, apply extra yellow and red to your image to mimic the effect of warmer daylight. Apply within the midtones only, as below.

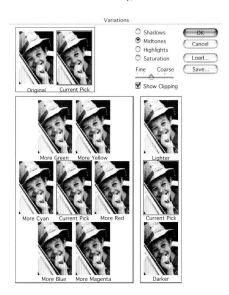

Step 3

Finally, apply a slight Saturation increase to your image to give an impression of strong sunlight.

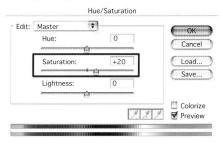

The corrected image

Changing individual colors

The simplest of all color edits can be made using the Saturation commands, which do not involve complex and time consuming selections.

Step 1: Process your image

This editing sequence allows you to make a simple color change without worrying about visible edges. It's most suited to solid color areas, i.e. those parts of your image where there is continuous color of a similar saturation and lightness. The process is least successful on image colors that are graduated from light to dark.

In this example, the solid red colors of the motor vehicle grill will be changed to a more eye-catching green color. With the red color contained in its own distinct territories, there's no danger of the editing overspilling into other image areas and giving the game away.

Begin by making all your contrast and color balancing adjustments, then choose the Hue/Saturation dialog from the Adjustments menu. Slide the dialog across your desktop to reveal the image.

Step 2: Choose the channel

Decide on the composition of the color that you'd like to change. In this example the duller red color was the obvious choice. From the Channels drop-down menu at the top of the dialog, choose Reds. This effectively means that subsequent Hue, Saturation and Lightness edits will only affect the red parts of your image, leaving other color areas intact.

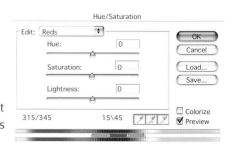

You'll notice that at the base of the dialog box, there are now two narrow ribbon bands of color with four grey markers. The top ribbon describes the image colors as they stand and the bottom ribbon shows the colors you can change them to.

The two vertical grey markers denote the exact color to be altered in the top ribbon, lying above the replacment color in the bottom ribbon. The two outer triangular markers control the amount of 'fall off', an effect similar to feathering whereby similar but not exact color values can be included in the edit to make it appear more convincing.

Step 3: Change the Hue

Start by moving the Hue slider until you get close to the kind of color change you desire. Don't worry at this stage if the color does not look exactly as you wish. You'll see the bottom color ribbon move as you move the Hue slider. In this example, a strong lime green color is earmarked as the replacement.

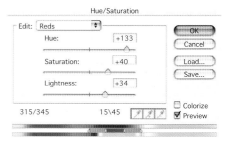

Experiment too with the Saturation slider by increasing the value for a more vivid effect or decreasing it for a more muted appearance. Finally, experiment with the Lightness slider to brighten or darken your new color creation. With this example, a kind of pastel color effect was created by increasing the Lightness value.

If there are areas of the image that persistently include themselves in the edit, quit the dialog, isolate the areas with a selection, then go to Select⋯⋗Inverse. Repeat your edit and watch these areas stay constant.

You can also edit your color by directly dragging the grey markers in the color ribbons.

The corrected image

Distressed color

There's no reason to print out all of your images with clean-cut edges, as it's easy to mimic the look of an enlarger mask edge.

Step 1: Channel mix your colors

A straight daylight shot of a flower has been produced, above top, but this is further processed into a more unusual version, above bottom, with the Channel Mixer controls. The purpose of the edit is to draw attention to a group of fairly ordinary flower specimens by altering the colors from pink to sky blue. Any color change is possible with this technique.

The Channel Mixer technique is detailed on pages 92-93 and works by changing certain colors around without causing negative/positive shifts. The resulting image still maintains its level of detail and full tonal range.

Step 2: Scan a texture

To create a distressed look, a second image was produced by scanning a vintage photography glass plate negative. Fallen from an uncased and badly damaged Ambrotype, the glass plate offered a fascinating texture that could be combined with the original image.

The skill in choosing texture elements is to find those examples that do not have regular or repetitive patterns which would look overbearing, but to choose irregular subjects that complement the main image. Suggestion rather than emphasis is the key to this decision.

The image of the tiny plate was acquired on a flatbed scanner using a very high 2400 ppi scan resolution, so it could match the size of the camera image. Always scan small originals with a high resolution so you capture every single remnant of inherent detail.

Creating a super high resolution scan allows you to resize your image to the exact size you need without resorting to excessive resampling.

Step 3: Combine and blend

Assemble your texture image below the photographic original in your Layers palette, as shown. This example maintained the presence of an irregular edge, so a further blank white Layer 2 was introduced at the base of the palette.

Click on the uppermost photographic layer and change the layer blend mode to Overlay. In this mode, the photograph now starts to mix and merge with the texture layer underneath to create a new and intriguing result.

Experiment also with the opacity of this uppermost layer, where less than 100% will produce a lighter, more ethereal combination.

The final example, shown right, was created using a 50% opacity on Layer 0, plus a 60% opacity on Layer 1 to blend with the underlying solid white of Layer 2.

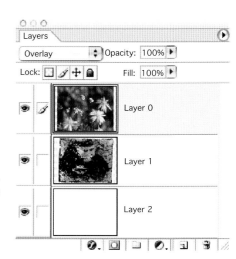

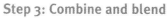

The finished image

Using the Channel Mixer

If you want to make an image color that defies logic, try using Photoshop's versatile Channel Mixer. Used to great effect in making monochrome conversions, the Mixer can also be used for color.

Starting point

Choose an image that has a good range of tones, but one where the original colors are not especially eye-catching. The process discards all original color values and adds a completely new feel to the end result.

Producing a result somewhere between a color and a monochrome image, yet retaining distinct colors in each tonal sector, the effect can really add the finishing touch to an otherwise disappointing image.

Make all your normal contrast adjustments before loading up the Channel Mixer, including emphasis effects using your burning in and dodge tools.

Step 2

Select Image----›Adjustments----›Channel Mixer and watch as the dialog box opens. Immediately, click the Monochrome option button, shown here in the bottom left hand corner of the dialog. The image will instantly lose all its color.

Next, unclick the very same Monochrome option box that you've just selected. Nothing will change in your image, as it is still monochrome in appearance, but you will see that there are now three options available in the Output Channel pop-up menu, found at the top of the dialog.

Now you can start creating your own unique color effects. Although you'll be starting from a completely monochrome position, color can gradually be introduced back into your file.

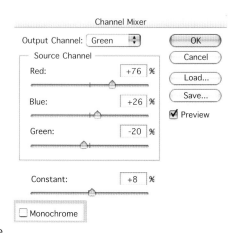

Step 3

Start by working on the Red channel, then carefully reduce the 100% value to around 70% and increase the values of Green and Blue to −20% and +20% respectively. Do the same for each color channel, but do not use these measurements as an exact recipe, but rather as a starting point since your image will be constructed from different colors.

With each channel edit, consider also adjusting the Constant value, found at the base of the dialog, if the image darkens or lightens during your processing.

Aim for a slight coloration rather than an overall tone effect. With this example on the right, the channels were adjusted so that slightly different colors ended up in the highlights, midtones and shadow areas.

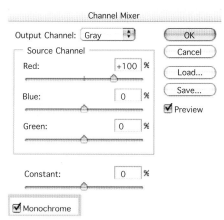

The finished image

Inverting color

Photoshop offers the opportunity to mimic the look of color infra-red film by color inversion and layer blending.

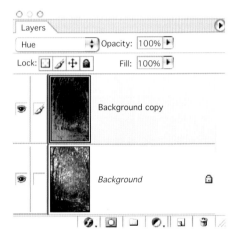

Step 1: Duplicate layers

The starting point for this project is a simple landscape, predominantly green in color. The aim is to create a color infra-red effect which reverses some colors but maintains the overall tonal range of the image.

Unlike a straight negative version of a color image, which is not visually attractive, this color recipe adds an interesting twist to an otherwise straightforward shot.

Start by making all your color and tonal corrections, and if there is more than one layer, flatten the image. Next, duplicate the background layer by dragging the layer icon over the tiny turned-page icon found to the left of the wastebasket icon at the base of the Layers palette.

Step 2: Invert colors

Next, make sure that the uppermost duplicate layer, called Background copy, is active, shown above colored blue. If the lower layer is blue, simply click on the uppermost layer to make it active and ready for the next edit.

From your Image⸱⸱⸱⸱⸱Adjustments menu, choose the Invert option, found right at the bottom next to Equalize, Threshold and Posterize.

Once applied, your image will completely reverse out and all colors will be mapped to their exact opposites. White becomes black and green becomes magenta. In this raw state, the image looks uninspiring and will lose some of its tonal subtlety. Don't make any other adjustments at this stage.

Step 3: Layer blending

The final step is to soften the color inversion edit by using a layer blend. Layer blends create unpredictable changes to your image by merging the colors of adjoining layers into one another in a technique that has no parallel in the real world of painting or photography.

Again, working on the uppermost layer, move your mouse over the pop-up menu found at the top left hand corner of the Layers palette, set to Normal by default. Click and hold until all the options are revealed. For this project, choose the Hue blending mode. Your image will now regain its tonal range but will be accompanied by new and delicate colors. To complete the edit, warm up using the Photo Filters and lighten in your Levels dialog to produce shadow details.

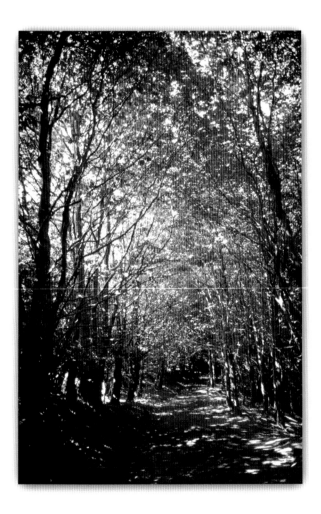
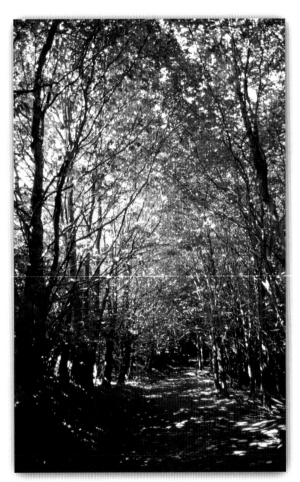

Above shows the enhanced image and above right shows the
unprocessed starting point for this project.

3D color

A simple edit with the Channels palette will create an eye-catching 3D image for print or onscreen use.

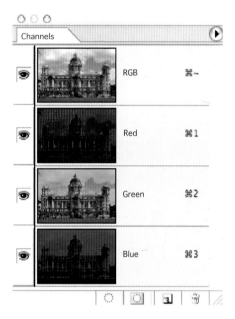

Step 1: Choose the image

Before starting this project, choose an image that has plenty of three dimensional detail and texture. This example of a façade has been modelled by the light to show sharp surface detail and is ideal for the technique.

Start by editing Photoshop's Display and Cursors Preferences to include Color Channels in Color. This will show each separate color channel in its own color, as in the example above. Most editing work is done on the composite RGB channel, set by default at the top of the palette, but for this project you will work on the Red channel only. Click on the Red channel to make it active.

Step 2: Move the Red channel

When your desktop display shows only the red component of your image, as shown right, you are ready to make the simple edit.

Choose the Move tool from your toolbox and place this in the centre of your image. Next, click and drag the image a few millimetres to the right. There's no need to move the channel too much, as this will fail to make the illusion work.

Once complete, reselect the RGB composite channel to see how the edit has affected the entire image. You are aiming to make an effect similar to the full sized example shown on the opposite page.

Step 3: Viewing

After completing the edit, you can preview the technique onscreen before committing to a print-out. To view the illusion, you will need to use a pair of 3D glasses, as shown below, wearing the blue lens over your left eye and the red lens over your right eye.

Move your head slightly from side to side to see the effect onscreen. If your image does not show the characteristic movement, you'll need to retrace your editing steps in your History palette and move the Red channel less.

Once refined, the technique can be used for making print-outs and even for images that are destined for onscreen use only. A good project is to make several images into a 3D slideshow, developing a Photoshop Action script to automatically process large numbers of images that would be too repetitive to do by hand.

When viewing 3D images onscreen, ensure that your slideshow is set to Kiosk mode, where all menus and other desktop furniture are placed out of sight.

The finished 3D image

Chapter 7

COLOR RECIPES

Cross-processing

A firm favourite with film photographers before the advent of digital, cross-processing is typified by colored highlights and unusual color combinations.

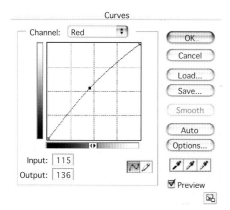

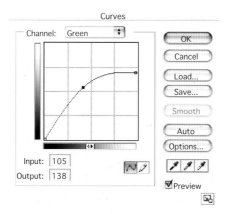

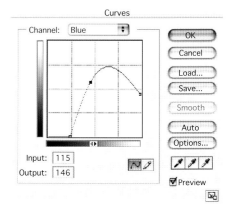

Starting point

This style mimics the effect of processing color negative film in color transparency chemicals, no doubt first tried in error, which creates a look that is still sought after for fashion and portrait photography. First, find an image that has plenty of bright highlights, texture and a good tonal range. The purpose of the process is to alter color values dramatically.

With the conventional process, results were so unpredictable that several exposures had to be bracketed to be sure of a usable result.

In the digital process, the effect can be mimicked by using a simple Curves command on each of the three individual color channels.

Start by pushing the Red channel into a slight arc as shown above, a light-handed start to the project.

Step 2

Next, choose the green color channel from the Channel pop-up menu at the top of the dialog box. Ensure that the Freehand Curve tool is selected, click on the exact middle point on the curve and push it upwards slightly.

Next, click on the highlight curve point, found at the end of the diagonal line in the top right hand corner. Drag this point downwards until it lies in the position as shown above.

As all images are composed of different color values and quantities, you may need to exaggerate these Curve commands to fit your own image file.

You can easily tell if you have overdone this stage, as colors will start to reverse out to opposite values. If you have gone too far, simply press Alt and Revert.

Step 3

The final phase is to edit the Blue channel, which will create the characteristic highlights. The aim is to produce a slight color change, with yellows starting to replace white, and blues appearing in the highlights.

Click on the middle curve point and push upwards, as shown. Next, click on the black shadow point, as found in the corner of the bottom left hand square, and drag this to the right.

Finally, click again on the white highlight point, found at the top right corner, and pull this down to create a half looped effect.

With this final move, your image will start to take shape and adopt the curious cross-processed appearance. Complete the image by burning in or holding back to extend the emphasis effect.

The final colored image

Converting color to mono

Shooting monochrome isn't really an option with color digital cameras, but Photoshop allows you to recreate many subtle film effects.

Many digital camera images would look much better in atmospheric black and white, but without grayscale available as a shooting mode, RGBs must be converted after capture.

With the endless possibilities offered by digital color manipulation, it's easy to reinterpret a color image as a punchy monochrome if you use an alternative method to a simple mode change. Complex color to mono conversions can enhance the individual color channels of an image and make colors darker or lighter than they were in the original subject.

Like false color photographic film, the original color channels of a digital image can also be re-mixed to create unique results. The principle involves replacing the quantities of each source color with a new color to create spectacular effects, not seen before with conventional photographic or reprographic techniques.

The Channel Mixer command, found in Photoshop alters the balance of image colors before making a monochrome end product. The Channel Mixer works by offering you the chance to make image colors lighter or darker than they really were in the original, much in the same way as black and white photographers have used deep color filters to make blue skies appear black and green foliage appear white.

Using the Channel Mixer

The most inspirational way to make stylish tonal conversions is to use Photoshop's Channel Mixer. You can achieve many different results, from a high contrast and high impact monochrome to a softer and more subtle color conversion. The key to the dialog box lies within the new values you select.

The Channel Mixer lets you re-establish the exact amount of each color in their individual color channels, so green can appear darker or lighter than it would do after a straightforward RGB to grayscale conversion.

To make a conversion, click the Monochrome check box in the bottom left hand corner of the dialog. Next, pick a color you'd like to emphasize and either decrease its value to darken it, or increase the value to lighten it. As each command is made, keep a close eye on the values appearing in the Red, Green and Blue Source Channel text boxes, as these must collectively add up to 100.

Once you have selected the Monochrome check box, increase the quantity of Green to the maximum +200% and enter −50% in both the Red and Blue channels. There's no hard and fast rule about using the Channel Mixer settings, but a final figure of 100 will ensure an even brightness range.

Low contrast color in this landscape can create different mono conversions. At the top is the original unedited color image, followed by two different Channel Mixer options. In the centre is the image after a mono Channel Mixer conversion on the Red channel, while the bottom version shows the same command on the Green channel. Recipes for these effects are shown above

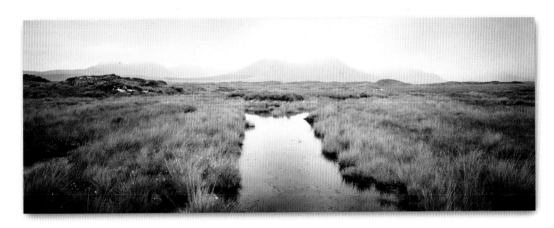

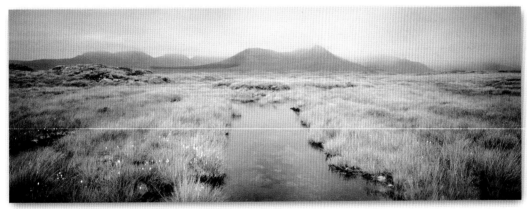

Split toning

A bad print can't be enhanced by applying a blanket tone over it, but good prints can be made to look much more subtle using the Duotone image mode.

It is possible to tone your image with two or more colors and even drop each color into a precise tonal sector of your image. Photoshop is packaged with several preset duotone recipe files which can be applied directly to any image and then printed out on any desktop digital printer. The duotone process is based on the use of two colors, usually black and one other selected color. Even more advanced effects can be applied in the three color Tritone and four color Quadtone image modes. The best aspect of applying tone in this way is that you can work with a set of colors and manipulate each one in up to ten different tonal sectors between highlight and shadow.

Step 1

You can begin with any image mode, but you must convert it to grayscale before starting off. Next, go to Image⋯⋙Image Mode⋯⋙Duotone. In the Duotone dialog box, black is set as the default first ink color while empty boxes are next to Inks 2 and 3.

Step 2

Click into the empty white square next to Ink 2 to reveal the Color Picker. Choose a mid-blue and type in the color description as shown. As soon as you have picked a color, Photoshop updates your image behind the dialog box to reveal its effect.

Step 3

Next define your third working color, but this time choose a bright orange. The effect of this color will seem to cancel out the previous blue, but you can bring it back later on. Your image should now look quite heavy, as below.

Step 4

Click on the diagonal line graph next to the black ink box. This brings up the Duotone Curve dialog box. Type 5 in the 30% text box, 30 in the 90% box and drop the 100% box to 98.

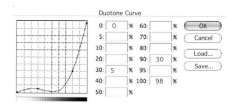

Step 5

Next, you need to adjust the blue. Type 40 in the 50% box and 77 in the 100% box.

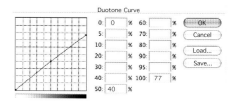

Step 6

Finally, adjust the orange to: 0 in 100%, 34 in 50%, 26 in 30% and 18 in 20%.

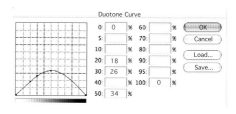

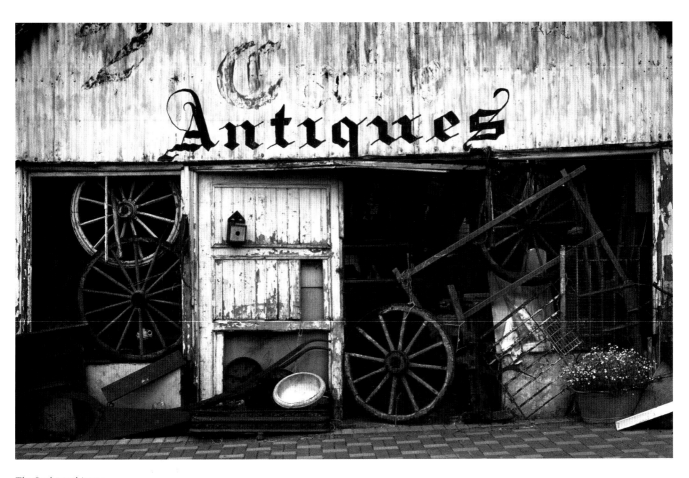

The final toned image

Emulsion transfer

There's an easier way of reproducing the look of a fragile emulsion transfer via a handy plug-in filter. With enough controls to personalize your work, the plug-in creates more eye-catching results.

Good value for money compared to the similar Extensis PhotoFrame, Auto FX Photo/Graphic Edges 6.0 comes equipped with over 10,000 preset edges, frames and border effects. The plug-in works with both Elements and Photoshop and as a stand-alone application.

Like all recent Auto FX plug-ins, the dialog box has two levels of help balloon which pop out when you dwell over a control, a function which really saves time and prevents frustrating editing for those who hate reading manuals beforehand.

Time spent finely tuning the control panels in this kind of plug-in will ensure your final result does not look obvious and gimmicky. Experiment, too, by varying the opacity of the effect.

The starting point
Although a striking image in its own right, this close-up study of a flower lacks a certain edge to the final edited result. After selecting the Photo/Graphic Edges plug-in, the Transfer option was chosen from the 14 categories available. This effect mimics the look of a wrinkly Polaroid image transfer and is a lot easier to achieve than the real thing.

When using the filter pack, opt for an original image that is simple and graphic, as this will not compete with the effect for your visual attention.

Navigating the dialog
Once opened, the Transfer dialog has sliders to vary the depth, contrast and starkness of the wrinkles, and to control the border width and color. In addition to these simple sliders, the software also boasts an Iron Brush and a Push Wrinkle Brush, so you can apply the effects by brush too. These latter controls can really help to make your work look hand rendered.

The final result
After a good deal of tweaking and wrinkle editing, the final result takes on a delicate and fragile appearance. Once you are happy with the edit, the plug-in allows you to save in most common image file formats including BMP, TIFF and JPEG.

Weblink
www.autofx.com

The finished image

Washed out color

Ethereal and low key color can transform a silhouette image and mimic the effects of a vintage photographic process.

Step 1

Many color images are naturally devoid of striking colors, even though grapically and compositionally they may still be worth persevering with.

Color images shot against a bright sky will always result in a virtual silhouette, as this example shows above, which can be an atmospheric way of describing a location. Images like this end up being much darker than you imagined when shooting. This is a result of underexposure by your camera meter, which reacts to bright areas of sky.

Start off by removing any residual color from your image by doing an Image····>Adjustments····>Desaturate command. This effectively removes all traces of color but leaves the image in the RGB mode, ready for future color editing. Unlike a mode conversion from RGB to grayscale, the Desaturate command leaves you ready to resume editing.

Step 2

To begin, open the image in your Levels palette and brighten the image. Do this by dragging the highlight slider left until it reaches the base of the mountain shape. Next, drag the midtone slider to the left until the image is bright without showing white.

Next, reduce the overall tonal range by working with the Output Levels sliders at the base of the dialog. Drag both highlight and shadow points into the centre, as shown, until your image adopts a subtle low contrast appearance which is now ready for coloring.

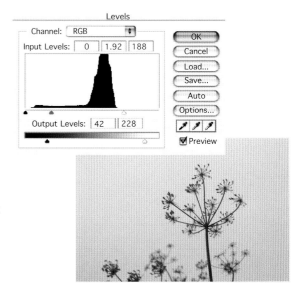

Step 3

The third step of the process is the addition of a delicate color once your image has been lightened. In the Image····>Adjustments menu, choose the Hue/Saturation dialog as shown here. Next, click on the Colorize option at the bottom right corner, then follow this with your own Hue selection and a reduction in the Saturation value.

The final image, seen opposite, was further enhanced by selecting the background foliage and gently applying the Motion Blur filter to soften it.

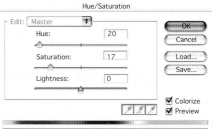

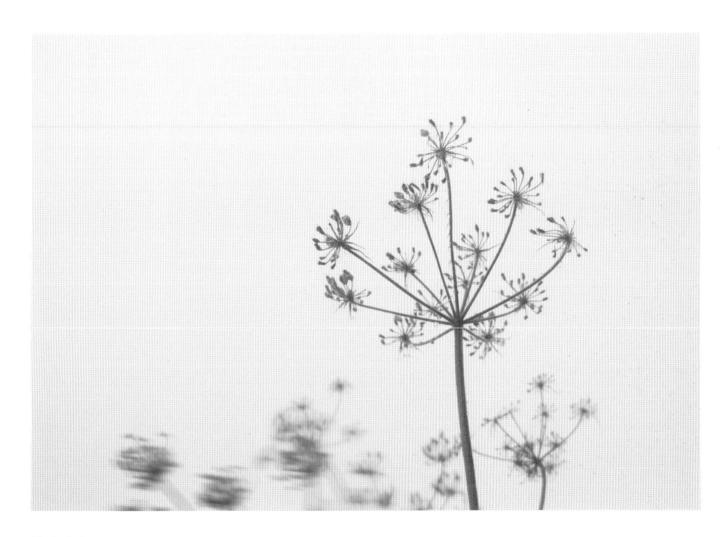

The finished image

Low key color

Mix your image modes and make creative use of Photoshop's brush tools for a delicate hand colored low key effect.

Step 1: Remove image colors

This process works by replacing image colors with new watercolor-like tones and can artificially age your final print to a bygone era. The final stage is to make a dark and low-key color effect that mimics a darkroom print.

Start by choosing an image that would benefit from the technique, such as one that has strong colors present, but some textural detail to play with.

The above example is a raw file shot on a very dull day, and as such the image lacks punch or any other visual qualities. However, the presence of texture and plenty of even midtone areas offers scope for adding emphasis effects later on.

Begin by converting your RGB image into a grayscale, then change again into Duotone image mode. This step is used to create an unusual pink background color rather than the usual grey.

Step 2: Tone with a duotone

Once in the Duotone dialog box, click on the Load button and choose one of Photoshop's premixed duotone recipe files. If you are not immediately transported to the right folder within your hard drive, do a simple Find command with your system software for the word duotones to trace its root.

Experiment with any one of the Process Duotone recipes, but aim for an effect that looks as weak and washed out as the example shown above.

Next, convert your image back to RGB to allow further color editing. Once converted, the duotone colors will remain unchanged, but you can add other colors on top with a paintbrush.

Choose a paintbrush from the toolbox, then change its color mode to Saturation as found on the Options menu bar. This mode will allow you to add a new color onto your image, which will have a reaction with your underlying duotone colors but without altering existing detail.

Step 3: Brushing and darkening

Before applying your colors over the image, reduce the tools opacity down to 30% or your edits will look too obvious. Select your brush color, limiting your palette. By keeping your colors related, they will blend in together better. This example was painted with dull orange, browns and dull reds.

Apply the colors using a range of different sized brushes on different areas of your image, aiming to meet shapes size for size with your careful brushwork. With the finished example, shown right, colors were gradually built up on top of each other rather than in a single brush stroke, to give achieve a more natural effect.

The final stage of the project is to reduce the overall brightness of the image by using the Levels or Curves commands. Aim to darken the midtones without creating deep shadows which would be difficult to print out effectively, especially on uncoated printing papers.

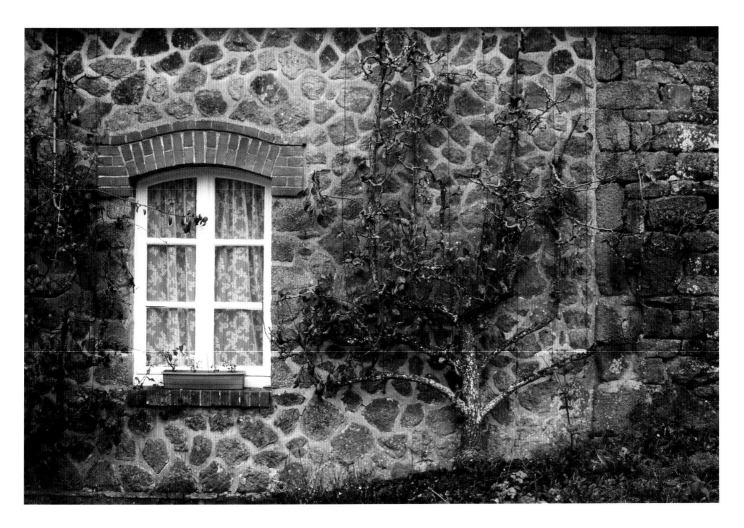

The finished image

Muted color palette

An evocative way of draining color from an image, the muted palette can recall a bygone era or just present your image in a completely different way.

Starting point

A great favourite with advertising photographers is a special color effect where intense colors are drained away, leaving a muted and subtle result. Both Photoshop and Paintshop Pro use an identical Saturation command to create this effect, found in the Hue/Saturation and Colorize dialog boxes respectively.

Choose an image that has full-on color which would benefit from the process. This example was drained of its color to give it a bit more interest. Once adjusted, the image starts to look dated, helped of course by the subject which does not tie itself to any specific date.

Next, bring up the Hue/Saturation dialog box in Photoshop. The Saturation modifier works by increasing or decreasing the intensity of color in your image or selected area. For this project, simply reduce the Saturation value until the image looks better. Too far and you'll get the equivalent of a straight conversion to grayscale.

Step 2

Next, adjust your color balance controls to make your image warmer. For this example, an extra amount of yellow was applied all over the image to enhance the weak colors and give the impression of a faded color print.

Use your Variations dialog box to achieve this effect, aiming for a delicate warm-up without increasing the saturation values that you've just taken away.

Notice on the example above that the extra yellow is largely visible in the neutral midtone areas of the floor covering. Compared to the example above left, the slight coloration really helps to make the image more eye-catching despite the loss of overall saturation. As a general rule, color casts are very difficult to spot in highlight areas and impossible in dark grey shadows.

Before the next step, consider which areas to darken in order to emphasize the main subject in the frame.

Step 3

The final stage is to darken some areas of the image to introduce a bit more contrast. Adding rich black areas will further enhance the dramatic effect of the muted style. Use feathered selections and your Levels dialog to darken down peripheral areas, as shown above.

An alternative ending to the technique is to restore some color saturation to tiny areas in the image to add further interest. You can modify the levels of color saturation by using the Sponge tool in Photoshop to paint back intense colors in specific areas. Set the Sponge tool to Saturate, with soft brush properties and a 20% value. If you go too far, choose the Desaturate option to correct.

In this example, tiny areas around the white edges of the book were enhanced with the Sponge tool to create more contrast than was previously present. The resulting image looks much more subtle and very different from the original.

The finished image

Autochrome

The Autochrome process was the first synthetic method of recording color in the field. As ever, things have come full circle and the process of using built-in mini color filters lies at the heart of today's digital CCDs.

First, open up your image and click on the Red channel in the Channels palette and watch your image turn completely red. From the Filters menu choose the Noise---Add Noise option. Noise is a very useful tool which adds a grain-like screen of pixels across any image, selection or channel. In the Noise dialog box, choose the Uniform distribution option, together with an amount of 50. Next, choose the Green channel and repeat the process, but this time using a different amount such as 60. The reason for this is to encourage a more random arrangement of noise to mimic the irregular screen of the Autochrome. Finally, apply the same filter to the Blue layer, again choosing a different amount such as 70 to complete the effect. Click on the composite RGB channel and watch the first mix of your grainy channels take place. At this stage the image will look like it has had a very uniform and somewhat crude texture screen applied, but more is revealed in the next stage.

Colors and brightness
The next step is to adjust your colors to make the image look dated. Autochromes fade to many different hues and saturation values, and you can control these all with one dialog box, Hue/Saturation, found within the Image---Adjust menu. To decrease the color intensity so as to mimic an aged color image, enter a negative value such −50 in the Saturation text box. Color drain will largely depend on the characteristics of your own image, but do experiment with variations. Brightness is controlled by your Levels midtone slider, as with preparing any normal image for print out. To gain more control over highlights, try experimenting with the Levels Output slider found at the bottom of the dialog. To mimic the dull highlight range of an Autochrome, move the Highlight slider, (the white triangle at the right of the Output scale) inwards to the centre. This will give your image a flatter and more aged appearance.

Color balance
Next, add a thick yellow adjustment to mimic the heavy shellac which was used to seal and protect the Autochromes' delicate layers. Rather than fiddle with the sensitive controls offered by your Color Balance dialog, opt for the more comparative Variations dialog. Turn the

Show Clipping option off and switch to a Coarse option. Experiment with the different sector controls such as Highlight and Midtone until you've achieved the result you desire. The most useful aspect of this control is the return option found by clicking the Original image on the top left of the dialog.

Peel-away emulsion edges
The delicate dye layers of an Autochrome were often damaged in handling, leaving characteristic white or bluish cracks. Just as the modern Polaroid image transfers adhere to their new paper support while leaving two out of three color layers behind, the Autochrome crack can reveal a single color layer, or just white. To make a convincing cracked area you need to work

on your Channels again and use nothing more complicated than your lasso tool. In your Channels palette shift-click on both the Green and Blue channels and draw a crude line with your lasso. Release the tool and watch how the application tries to make sense of your baffling selection by joining start point to finish. Next, select Edit ⤏Cut and watch a portion of your Blue and Green channels disappear. If it doesn't look convincing, do Edit⤏Undo and try again. What you are aiming for is a sky blue 'hole' to appear at the edges.

Vignetting and fading

Most vintage images have some form of darkening at the edges, so this can give your print an added layer of deception. Start off with your eraser tool and gently rub away the hard edges of your image to reveal a softer and more jagged perimeter. The underlying black layer should show up your work to good effect.

Although there are countless third party filters, textures and edges that claim to do this kind of thing, they will all start to look fairly predictable after a while. The best option is to use your own judgement and creativity. Select the perimeter then go to Select⤏Transform and then Shift+Alt your marquee into the centre of your image. Next, apply a feathered edge to your selection and then create the vignette by moving your Levels midtone slider to the right. Don't go overboard with this, as it will start to look obvious.

Soft focus

Many historic images were further protected from the dual elements of man and nature with the addition of a protective glass cover sheet. As the process was derived during the height of the Pictorial movement, many

photographers chose to install an etched or frosted glass cover to add a soft focus effect to the presentation. A much easier way to achieve this is to blend Photoshop's Gaussian Blur filter. Don't apply this directly to your image layer, but make a duplicate of this layer and float it above.

This way you can have the best of both worlds: a separate blurred layer which can be blended with the sharper one underneath. To the duplicate layer add a large amount of Gaussian Blur such as 20 pixels and watch your image lose its

The above example shows the full technique including distressed edges when applied to a straight color image

hard-won granularity. Next, to make this blend in with your original underlying layer, move the Layers Opacity slider to around 40. This will have the effect of allowing the sharper layer to visually emerge and will add an attractive cloudiness to the project.

Experiment with the effect by choosing different opacity values. The highest values give the most cloudiness, and the lowest give the most sharpness.

Chapter 8

COLOR TECHNIQUES

---> Print emphasis

---> Adding graduated color

---> Color to duotone

---> Plug-in filters

Print emphasis

After applying your tonal and color correction, the next step is to draw out emphasis from different parts of your image using a range of Photoshop tools.

What makes a good print?

Taking a stunning digital photograph is only one half of the task. Making a print that does it justice is far more time consuming and never happens by accident.

The definition of a good photographic print is identical for both digital and silver-based photographs. Good prints exhibit a rich tonal range between small areas of full black shadows and clean white highlights; fine details are present and visible without the need to scrutinize at close distance. Finally, the principal

subject should be clearly emphasized using variations in light and dark to direct the viewer's attention away from any irrelevant details. Poor prints have a compressed tonal range, lack any emphasis and hide image detail under dark shadow areas.

What emphasis means

The best conventional photographic prints undergo an extra stage in the darkroom when individual areas of the print are darkened down and lightened up to create a much more sophisticated image. Natural and artificial light will never fully draw out each individual part of an image, so this emphasis is added at a later stage.

Just like the moody dark and light effect used by great painters such as Rembrandt, photographic burning and dodging can help to make an image look three dimensional and inviting. In addition to these tricks, small offending image areas can be darkened down and made less noticeable, diverting the viewer's attention onto the main subject. For problems caused by camera underexposure, dodging will restore brightness to an area in the same way. This technique looks at a better way of burning and dodging than Photoshop offers via its standard toolbox, and if you've got some darkroom experience, then it could change the way you manipulate your images for ever.

Burning in with selections

Use the Lasso tool and make a very rough selection of the area you'd like to darken. Next do a Select⸱⸱⸱▸Feather and set this to 5% of the pixel width of your image. Then, with the softened selection still active, apply a midtone Levels command to darken down the area.

Using the Burn tool

The Burning in tool is used with standard brush properties and is best set with a round, soft edged brush and a low exposure value like 20% applied in the midtone values. Drag across lines in your image to give them greater emphasis.

The enhanced image

Adding graduated color

If you've been shooting landscapes on transparency film, you can rescue those pale, washed out skies by burning them in with the gradient tool.

Weak and insipid skies will always detract from the most striking of images, but you can enhance them with a clever Photoshop routine.

Adding straight palette color to a digital photograph in a convincing manner is much harder to do than applying color sampled from the image itself. Your choice of color, taken from the seemingly infinite Color Picker, will always appear alien if applied straight to the image.

Rather than applying alien color using standard paintbrushes with opaque color, this technique allows you to blend color seamlessly into your existing image without a trace of suspicious editing.

The end result looks just like a graduated lens filter effect, where richer colors are used to enhance pale originals.

Editing gradients

Open the Linear Gradient tool from the toolbox and choose the Gradient editor from the Options menu. By default, the tool creates a gradient from Foreground to Background, but for this project you need to choose the Foreground to Transparent option, as shown here. If you have a different Foreground color selected, this color will be reflected in the icons.

Applying gradients

When click dragging the gradient tool across your image, your start and end points define the length of transition from Foreground to Transparency. Near right is a gradient applied within a short space creating a sudden color transition. Far right is a more gradual transition where a greater gap is made between the start and end points of the gradient tool.

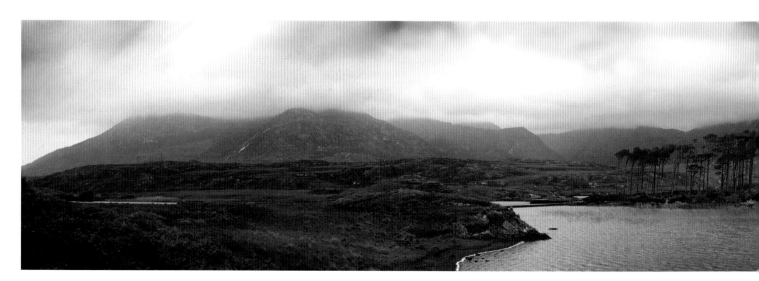

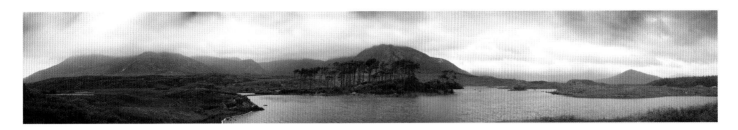

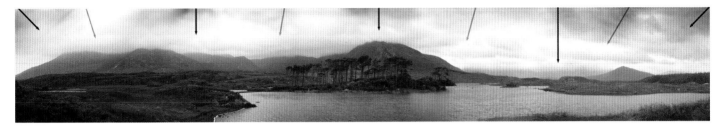

Choosing color and mode

From the Color Picker choose a bright orange, even though it may appear too saturated for a photo edit. This intensity will be reduced by the mode and by a subtle reduction in opacity, but you can't mix two different colors together.

Next, from the Options menu, change the mode from default Normal to Color.

Before applying the gradient, check that you have selected the Linear Gradient tool variant.

Positioning the gradient

Above top is the starting point for the project and above bottom shows where to draw your gradients. Don't aim to get the entire image edited in a single gradient. A much better option is to apply several gradients in slightly different but overlapping directions. For a straight line effect keep the Shift key depressed when drawing your gradient.

When working at the corners, angle your gradient inwards as shown.

Varying opacity

Above bottom shows you how to vary the individual gradients. The black arrows denote the first gradients, applied at 40% opacity. The lighter grey arrows show where to apply the second phases of gradients, but this time at a less intense 15% opacity.

Keeping the opacity setting low means you will create a more subtle and blended end result, as shown below. Use your History palette to correct any mistakes.

Color to duotone

Once loaded and manipulated into shape, duotone images can rival the most skilfully toned photographic print ever made in the darkroom.

Where color photography is a chocolate box of different visual treats, black and white is just about light and its stunning effects. Many photographic situations do not present the photographer with a rich and varied selection of color and indeed may look insipid and uninspiring.

With a black and white conversion in your image editing application, undesirable colors can be removed and replaced with a punchier tonal range for a better visual effect. Color can easily date a photograph to a particular year or season, but a simple change to monochrome creates a more timeless and classic image. It's impossible to previsualize a black and white photograph while shooting on location, but you'll get great quality results if you concentrate on some or all of the following essential elements.

Subtle contrast subjects

The different shades of grey arranged between the black shadow and white highlight point is called contrast in traditional photography and is referred to as brightness in digital imaging. Pixel brightness can be made darker and lighter very simply and this allows the skilful user to separate and enhance different areas of the image to create a totally different visual balance. Unlike straight color photography where little tonal manipulation can occur without looking invented, black and white interpretation can be highly individualistic. With a good mixture of pure black and white

and a full range of greys in between, the subtle contrast image presents a seamless jump from highlights to shadows.

Software controls like Levels and Curves are ideal for putting proper black and white points into a low contrast image and can also be used to shift the balance of the midtone greys.

In addition to correcting low and high contrast images, software tools can also give the user an opportunity to express their own creative ideas through the printed end product. Subtle contrast with a color change to enhance your images can be produced using Photoshop's versatile duotone mode, where up to four individual colors can be assigned to precise tonal sectors in an image. Best of all, you don't need to be an expert at using Curves to control contrast, as Photoshop comes armed with loads of premixed duotone color recipes that you can apply directly to your images by pressing the Load button in the duotone dialog box.

Starting off

Convert your RGB image to grayscale then duotone mode. Select the duotone option from the top pop-up menu. To select a color, click in the box underneath the black color square and choose from Photoshop's Color Picker.

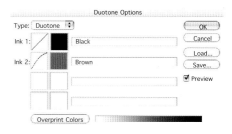

Step 1: Choose your colors

Stick with black as the default shadow color, but choose a saturated brown as the second color for this edit.

Step 2: Reduce black

Click on the black curve and type 30 in the 50% text box and click OK. This reduces the amount of black in the midtones.

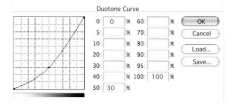

Step 3: Increase color

Click on the brown curve and type 70 in the 50% text box. This increases the amount of brown in the midtones and creates the warm toned effect.

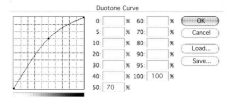

Above top shows the unprocessed image in RGB mode.
Above middle is the conversion to grayscale mode
Bottom shows the final duotone mode version.

Plug-in filters

Plug-ins are very useful additions to your image editing application and can be installed with the minimum of technical fuss.

Made and distributed by third party software companies such as Extensis, plug-ins are designed to work within Photoshop, Photoshop Elements and other major applications. Plug-ins extend the usefulness of your editing application by adding new functions or filters to the standard Adobe filter pack.

Creative filters, wacky edges, color effects and lighting effects form many of the plug-in packages, but there are more sophisticated ones for dealing with cut-outs, sharpening and even image compression. Once installed, plug-ins appear as an extra item in your drop-down menus, so you can access them with ease. Working in the same way as other Photoshop components, plug-ins process and package your image just like any other command.

Like Photoshop's Extract command, most plug-ins are operated via a comprehensive dialog box where you can see the likely effects of your handiwork before committing to the edit. Most plug-ins can be bought over the Internet, either in mail order form or as a downloadable file. Best of all, most plug-in manufacturers offer trial versions of their software through a free download.

Trials are essentially limited versions of the full package and offer either reduced controls or produce the final image with an indelible watermark.

There are many plug-ins for Photoshop and even more specialist plug-in portals on the web where you can find quick links to websites without wasting time surfing. Plug-in filters vary from the totally free product invented by the Photoshop enthusiast to top dollar packages aimed at the professional end of the market. Like many other software applications, free doesn't necessarily mean good, with the most effective products costing money.

The best way to test your plug-ins is to test the trial versions, especially if you have concerns about the compatibility of your operating system or version of Photoshop. Like many full blown image editing applications, you can even pay to upgrade your plug-ins when newer versions arrive on the market, so your initial investment remains useful. Once downloaded from the net or loaded onto your PC from a CDR disc, plug-ins are usually self-extracting and install themselves into the relevant folder on your hard disk. If this is not the case, you need to ensure that the plug-in is placed in the correct folder, or it won't work. On a Windows PC, drag the plug-icon into this folder location: C/Program files/Adobe/Photoshop/Plug-ins. Next, relaunch your application and then check to see that the plug-in has become visible as a new menu item. If it doesn't

show, check that you have dragged the right component of the plug-in to the right folder on your hard drive, or check that the plug-in isn't still in a zipped folder.

When Photoshop and Photoshop Elements were re-designed, Adobe created a common 'engine room' for both applications. This in effect means that many plug-ins work perfectly well in both and can even be re-used when upgrading from Elements to the full Photoshop version.

Using the raw uncorrected file shown above as a starting point, Flaming Pear's Melancholytron plug-in filter was used to create a much more atmospheric result, opposite

Chapter 9
SPECIAL TECHNIQUES

---> Softening

---> Color toners

---> Polarizing filter

---> Old and new

---> Using transfer paper

Softening

To recreate the look of a vintage soft focus print, apply a diffused effect to your image with a gentle application of the motion blur filter.

Starting point

Many images benefit from an extra processing sequence that strips away all sharp focus and detail. A process taken straight from the professional darkroom, softening will add an extra layer of intrigue to your print.

Start by choosing an image which is not dependent on fine detail remaining in the final print. This example shows a recognizable landmark, but the task is to make it look more memorable than a straightforward shot.

Just like applying a diffuser over the enlarger lens, this technique bleeds shadows into highlights and also blurs the edges of strong graphic shapes within the image.

The trick with this technique is not to make it look like a straight Photoshop filter effect, as this can look as obvious as a screw-on lens filter. By modifying the filter effect with the useful Fade filter command, you can really blend your edit and original together.

Step 1

Once you have selected a graphic image, apply all color and tonal edits before moving on to the softening sequence.

Open your Layers palette and create a copy of your background layer by dragging the background layer icon over the tiny duplicate layer icon, found to the left of the wastebasket on the palette baseline. The purpose of creating a duplicate is to have an identical version of the image to soften, then blend with the underlying sharp layer.

Ensure that the Layer Blending mode is set to Normal and the Opacity is set to 100%. Next, click on the uppermost layer, as shown, as the softening edit will be applied to this rather than the background layer. From the Filters menu, choose Blur⸱⸱⸱>Motion Blur and drag the dialog box away from your image onto the desktop so you can see the edit take place.

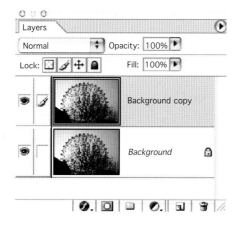

Step 2

In the Motion Blur dialog, set the Angle to 30, or follow any naturally occurring lines in your image.

Next, move the Distance slider to a 90 pixels setting and watch how the image loses all its sharpness and detail.

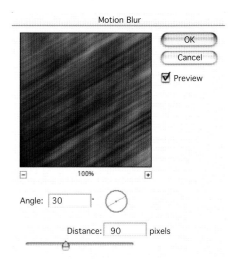

Step 3

Immediately go to the Edit⸱⸱⸱>Fade Motion Blur Filter command and reduce the Opacity from 100%. Next, change the blending mode to Luminosity and watch how the layers of your image recreate this effect.

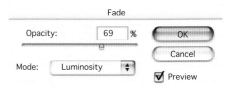

The finished image

Color toners

There are many different methods for adding new color to a digital image, but this process offers a simple way of controlling color in different tonal sectors.

Step 1: Desaturate

Conventional photographic color toners are versatile chemicals that can transform a modest image into something special. Although Photoshop offers several different methods of digital toning such as the Duotone mode, the Hue/Saturation command and even the Photo Filters, this method is simple and straightforward.

Start by choosing an image that would benefit from an all over tone, such as the example shown above. Make your first edit by adding your desired tonal and emphasis effects, then remove all traces of existing color by completing an Image···>Adjustments···>Desaturate command.

Once in a monochrome state, but still in the RGB editing mode, the image is now ready for color toning. Opt for a color that emphasizes the subject matter; in this case a cool blue helps to develop the feel of a hard edged, modern building.

Step 2: Color the highlights

Open the Color Balance dialog box and drag it away from your desktop image so you can see the effects you are creating. In the Tone Balance section of the dialog, found at the base, change the default Midtones setting to Highlights.

This command allows you to introduce new color into the highlight and lighter pixels in your image. Start by adding the lighter hues such as yellow and cyan to the highlights until your result resembles the example above right. Don't be concerned if it starts to look very different from your intended end point, as you will introduce another color on top of this in the next stage.

Step 3: Color the midtones

Without quitting the dialog box, select the Midtones option in the Tone Balance section. You will see that the color sliders have now been reset to zero, ready for your next edit.

Start by adding the darker colors into your midtone areas. This example used blue and a touch of cyan to create the effect shown on the opposite page.

The method works successfully without ruining your carefully edited contrast and emphasis effects, and the image looks much better than if it had been edited with a single overall wash of color. Other good colors to try are copper, the brownish sepia and the purply-red selenium.

The finished image

Polarizing filter

You can easily recreate the look of a polarizing filter in Photoshop and bring out the dramatic colors in cloudy skies.

Step 1

The method avoids the need for making painstaking area-based selections that would be near impossible to do around complicated shapes such as these trees.

Start by making all necessary contrast and color adjustments to your image before you add this polarizer effect. Ensure that you leave any sharpening until this process is complete, as it could increase the amount of visible noise in your image.

From the Image⸳⸳⸳⸳Adjustments menu, choose the Selective Color option. From the drop-down Color menu at the top of the dialog box, choose the Blue option.

This command determines that only pixels colored blue will be included in the edit. If there are any blue pixels elsewhere in the image, they too will be affected by subsequent editing.

Conventional polarizing filters work by allowing certain wavelengths of light through a camera lens while blocking others. The result can be visually startling, with some colors becoming richly intensified without changing the characteristics of others.

Useful on hazy days when light rays are bouncing around in all directions, the conventional polarizer extends normal exposure times, which could prove inconvenient.

This Photoshop process can be applied to any raw image, providing the right mix of cloud and pale blue sky is present.

Step 2

Next, move the Black slider as far to the right as you can, until the blues in the image start to visibly darken. The process effectively darkens all blue pixels present in the image to mimic the deep blue color of a polarizer. Unlike a color saturation edit, the color intensity of the blues will not increase, but rather they will stand out more against the white clouds.

To make the edit more convincing, repeat steps 1 and 2, but choose the Cyan option from the Color menu in the Selective Color dialog box. All blue skies will contain an element of Cyan too, so this final process will further increase the deep color of the sky.

Before printing, try sharpening with the Unsharp Mask filter, but use a small amount such as 50 or less to avoid increasing noise.

The finished version

Old and new

Use Photoshop's History Brush to mix together different versions of your work-in-progress without using layers.

Starting point

The beginning of this project uses a raw image file which was captured using bounced flash in a very dark interior. Despite the successful exposure, the image has lost all of its original character and atmosphere, owing to the effect of the artificial light.

The idea behind the old and new process was to re-instate original lighting, but also to alter the original color values to artificially age the photograph.

Using the Channel Mixer, the original color values were altered to provide a muddier range, with each step of the process saved as a History Snapshot to allow an easier return with the History brush at the end of the sequence.

With three Snapshots to work with, elements from all three versions could be combined in one final image, without resorting to masks, layers or complex selections. Ensure that you save each stage of your edit as a Snapshot by clicking the tiny camera icon found at the base of your History palette.

Creating light fall off

Make a rough circular shaped selection around the area you want to preserve, then choose Select⋯⫯Inverse. Next, apply a Select⋯⫯Feather:120 pixels to soften the edge. Finally, do a View⋯⫯Extras command to remove your visible selection edges.

Bring up your Levels palette and drag it into a corner of the screen where it doesn't obscure your image. Click hold on the grey triangular Midtone slider and move this gently towards the white triangle to the right to darken.

Aim for an effect that removes all unwanted details from the edges of your image, as shown, right.

Snapshot and restore

Save your Snapshot, then make a Channel Mixer color edit, as described on page 92. At the end, again save your Snapshot. Next, select the History brush and set it with large soft edged brush properties. Then, without changing Snapshots, click into the History palette next to the Snapshot you want to rub back to, as shown right.

Gently brush your image to reveal the previous Snapshot details. If you make a mistake, simply click on your final Snapshot and start over. Change brush size when you get into corners.

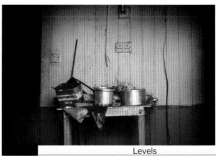

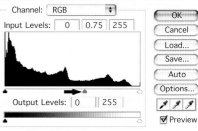

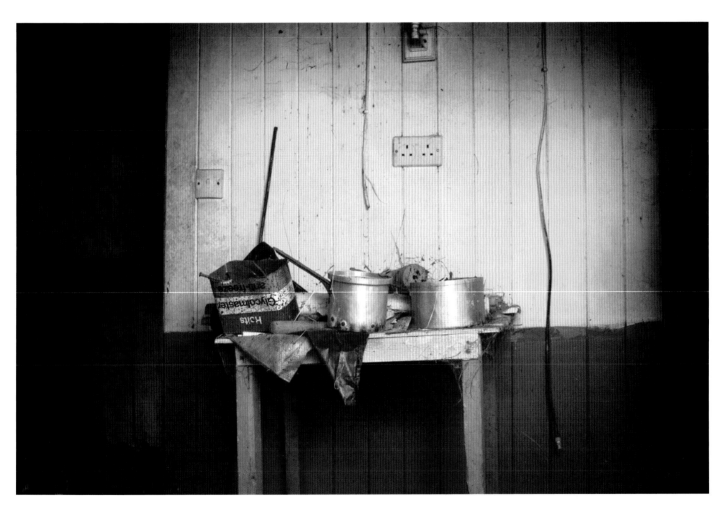

The finished image

Using transfer paper

Transfer paper is a clever kind of inkjet media that allows you to iron your images on to fabric, textured card and even personalized t-shirts.

Step 1: Get your design ready

The start of the t-shirt transfer process begins at the end of your image editing. Transfer prints can be any shape and can even contain accompanying text, as this design shows. Even delicate detail is retained, so you are not limited to using bold or graphic source images. Remember, any whites in your Photoshop image will take on the base color of your t-shirt material.

There are no hard and fast rules when choosing an image for a t-shirt transfer but simple and graphic shots work best. The most important issue to bear in mind is that the highlights of your image will be defined by the fabric you are using, so white is best and darker colors simply will not work.

Step 2: Flip your design

With t-shirt transfer paper, your inkjet printer actually prints onto the reverse side, so you need to flip your design before print-out. To make sure that your image is the right way round after ironing on, choose the Flip Horizontal option in your Advanced printer software dialog box. This leaves your image unaltered, but flips during processing.

Instead of printing directly onto fabric or shiny self-adhesive labels, special peel-apart papers have been designed which respond much better to inkjet inks than rough fabric or cheap office media ever would. After printing the transfer is bonded onto fabric by heat and becomes completely permanent and washable.

Step 3: Flip in your image editor

If your printer software doesn't have the Flip Horizontal function, then you can easily prepare your file for print-out in your image editing software. In Photoshop make an Image→Rotate Canvas→Flip Horizontal command and watch your image reverse itself. Any text should now be mirrored, as the above example shows.

Smooth, white natural fabrics such as cotton without seams or stitching in your transfer area will give you the best results. Image shape is entirely up to you, with letterbox or circular designs looking great on t-shirts. There's simply no reason to stick to a full A4 sheet.

Step 4: Set your media type

Better transfer papers are supplied with in depth instructions for setting up your printer software properly. Most Epson printers have a special Transfer Paper media option, but if this is not the case, choose the Plain Paper option instead. This will ensure the right amount of ink is dropped onto the media. Set your printer resolution to 720 dpi or Fine.

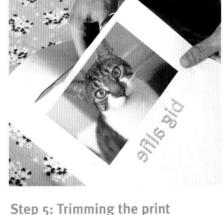

Step 5: Trimming the print

After printing out your design, the colors will appear duller than you expect, but this is perfectly normal as you are looking at the reverse side of the print. Before applying to your material, trim off the excess paper, leaving a 5mm border around each edge of your design. The smaller you can make this, the less visible the transfer will appear on the fabric.

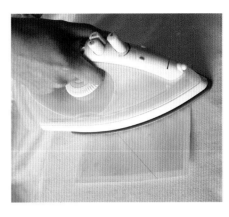

Step 6: Ironing on

Place your t-shirt on a hard wooden surface such as a piece of MDF and then position your design with the backing paper facing upwards. Apply a hot iron to the centre to tack down, then make three presses to each edge of your transfer. Use the tip of the iron to press down the corners firmly.

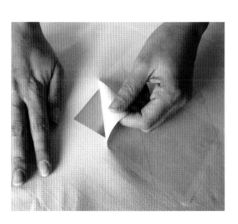

Step 7: Peel off

After completing your ironing, wait for at least two minutes for the paper to cool down. Next, gently pick at one of the corners with your fingernail and pull up the backing paper as shown. If the transfer hasn't bonded to the fabric, use your iron again to seal the edge and leave to cool.

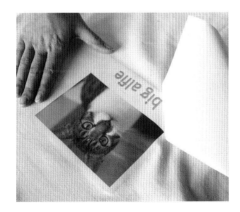

Step 8: Remove the paper

Once bonded, gently remove the entire sheet of backing paper. To avoid rips, clamp the fabric with your free hand as you remove the paper carefully. The design should now be right reading and much brighter than your initial print-out.

Step 9: Ready to wear

All transfer t-shirts can be worn and washed like any other garment, but care must be taken when ironing and drying.

Chapter 10

TROUBLESHOOTING AND RESOURCES

···> Troubleshooting White Balance

···> Framing color prints

···> Print composition

···> Print longevity

···> Jargon buster

Troubleshooting White Balance

If your digital photos keep turning out with a curious color cast, it's probably because you haven't set the White Balance correctly.

Curious as it may seem, both natural and artificial light in their many forms have very different color values. We're never aware of subtle differences in light color, as our eyes automatically adjust to compensate and this leads to a false sense of security when we think the camera will respond in the same way. White light is a perfect mix of all the colors of the rainbow, but artificial light emits a much narrower spectrum, resulting in a color bias. Unlike the human eye, photographic film and digital sensors are designed to respond to a narrow range of light, typically neutral, noon daylight. When exposed under different lighting conditions, conventional film appears dull and unexpectedly colored. Digital cameras have a built-in White Balance control to take account of the many different sources of lighting and are much more versatile than their film counterparts. It's vitally important to eliminate color casts in the shooting stage, or they will suppress other strong colors in the image. When not selected, most cameras default to Auto White Balance mode, but it's much better to choose the specific setting for the job. Commonly, mistakes are made when shooting under fluorescent lighting with a Daylight White Balance setting, with the image turning out a disturbing shade of green. Tungsten lights, otherwise called domestic light bulbs, also create problems by making a giving warm orange cast to your images. Both problems can be easily solved by selecting the correct White Balance option before shooting. Although the most severe of casts can be removed in your image-editing package, the less corrective editing your image needs, the better image quality you'll achieve in the long run.

Found on all but the most basic digital compacts, the four common settings are Auto, Daylight, Fluorescent and Tungsten, which can be set for each individual shot.

Better cameras provide extra settings for cloudy daylight, flash and even variations on different fluorescent tubes. Great for using when sunlight disappears, the cloudy daylight setting works by warming up images that would otherwise look blue, cold and uninspiring. This setting can be used to good effect when shooting with flash in both fill-in and full-on mode. Designed to be colorless, flash light can often strip a scene of all character, making bleak and unflattering end results.

Shot with the Tungsten White Balance setting, the result is a cyan and blue cast ▶

Correcting White Balance errors

Unlike slight color casts caused by fluctuations in natural light, casts created by artificial lighting can be tricky to remove. Most normal color balance corrections can be made using Photoshop's Variations or Color Balance dialog box where the cast is best removed in the midtone areas only. Yet if you've shot an artificially lit scene with the wrong White Balance setting, the color cast needs to be removed in the highlight areas as well. Start the process by opening your image and then selecting the Highlight option in your chosen color removal tool. Remove the cast, then select the Midtone option, remove the weaker cast and your image will be fully corrected.

Advanced White Balance control

Professional photographers have used color correction filters on their lenses for many years. Delicate orange and blue filters have been used to warm up or cool down lighting without adversely affecting color balance. Especially good for enhancing skin tones, these warm up lens filters create more flattering results. With many advanced digital cameras, custom White Balance settings can be created, so you can make and store your own versions of these traditional lens filters for future use. Designed as a hand held reference card, the Warmcard products are printed with a special color and are used to take a reading and to create a custom White Balance setting.

Shot under natural daylight

Although natural daylight is a constantly changeable light source, the best White Balance setting to use is Auto, as this will not remove any unique color characteristics present in your environment. Mistakes are easy to spot when incorrect White Balance settings are selected: normally white highlights become flooded with the 'corrective' color.

Weblink

www.warmcards.com

Below left:
Shot with the Fluorescent White Balance setting, the result is a magenta cast

Below right:
Shot with the White Balance set on Daylight, this image is correctly color balanced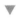

Shot under tungsten light

Otherwise referred to as incandescent lights, these types of artificial light source emit heat together with a reduced spectrum of light containing usually orange and red. Domestic light bulbs produce a yellow/orange cast when shot under a Daylight White Balance setting, but this can easily be corrected using your image editor.

Top right: ▶
Shot with the White Balance set on Daylight, the result is a yellow and red cast

Below right: ▼
Shot with the Fluorescent White Balance setting, the results is a magenta cast

Below left: ▼
Shot with the Tungsten White Balance setting, this image is correctly color balanced

Shot under fluorescent light

To compound a photographer's technical demands, there are just about as many variations in the type of fluorescent tubes as natural daylight. Fluorescents emit a narrow spectrum of light, usually green-only wavelengths. Tube manufacturers will provide exact color temperature values, so you can create custom White Balance settings on your camera to compensate.

Top right: ▶
Shot with the White Balance set on Daylight, the result is a green color cast

Below right: ▼
Shot with the Tungsten White Balance setting, the result is a yellow and red cast

Below left: ▼
Shot with the Fluorescent White Balance setting, this image is correctly color balanced

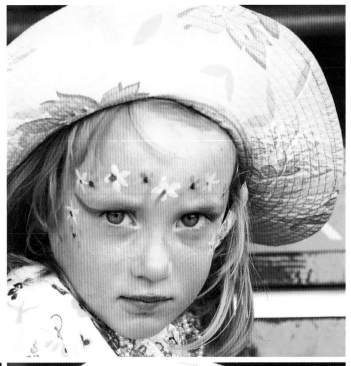

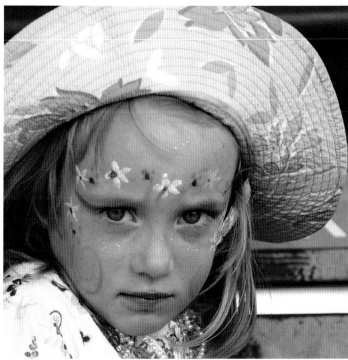

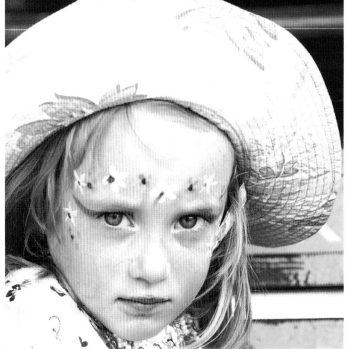

Framing color prints

The final step in the production of a digital print is to display your hard work within a carefully considered frame and mount combination.

There's simply no sense in relegating your best work to a dusty old portfolio or print box. Instead make a feature of your hard-won skills by framing your greatest hits. Not only can you show off your talents, but it's a great way to break the mould of predictable Christmas presents.

Paper and ink types

Prints for permanent display need to be made on the most durable inkjet paper, or on conventional photographic paper via an Internet print lab. Just like conventional photographic prints, excessive light will fade bright colors, so you really need to use top quality products. Top of the list is the acid-free 100% cotton Somerset velvet inkjet paper, designed to last a lifetime and available with a smooth or textured surface. The paper responds well to most glossy inkjet media settings in your printer software dialog and is especially good at reproducing vivid color. Good paper deserves good ink as these will extend the lifespan of your image for several years. If you don't use a pigment based inkjet printer, you may still be able to use special archival inksets made by Lyson. Available for many Epson and Canon models, these inks will really last the distance and allow you to display your work in brightly lit rooms.

Framing styles

Generally speaking, photographic images look best when presented against neutral mounts such as white, cream or midtones. Anything stronger will start to influence the color balance of your print. Natural wood frames, as found in Habitat and Ikea, are best for your more sensitive subjects, with aluminium or silver looking great around hard edged graphic images. Make sure you buy your frame first, as it's much easier to make the print fit the frame than vice versa. For a sequence of family images, try a multi-aperture frame which can accept four or more prints.

Mounting boards

For exhibition display, the safest and most practical way to show your work is within a hinged window mount made from acid-free mount board. Made from two identical sized boards, one with a cut window aperture and the other a solid back, the window mount will hold your print in place without the need for adhesives. If you can't get hold of acid-free board, try using Daler board instead. Found at all good art shops in a rainbow of different tones, the right color is best chosen with your print to hand, so you can see how one affects

the other. Bevelled edged mounts are the style to go for, but you will need to buy a special angled cutter to do this tricky job. If you don't feel like the challenge, then your local framing shop will cut a custom mount for you.

Archival considerations

Glues and spray fixings are all very bad news if you want to ensure the maximum lifespan of your work. All chemical substances can potentially react to your print paper and inks, so it's best to avoid them at all times. All paper media will expand and contract in response to changing environmental humidity, even when encased in glass-fronted frames. Prints that have been stuck in using quick fix masking tape will in time crack, buckle or even tear. A much better idea is to use large acetate photo corners underneath a window mount to keep the print in exactly the right position. Without attaching any adhesives to the print surface, the humble photo corner will allow the print to expand and contract and won't be visible in your frame. The invisible mounting of prints, used when the four edges of the print need to be visible, can be achieved with acid-free linen hinging tape, as made by Lineco Inc.

Four examples of frame and mount color combinations.
Each option permits the color of the print to dominate

Print composition

There are many different methods of presenting your finished image on paper, but which will prove to be the most eye-caching?

Borderless

Most often connected with the universal photo lab print, the borderless style is most suited to small sized output. Destined for photo albums or slipping into cardboard window mounts, borderless prints are more functional than decorative in style.

Produced by default by many direct printing devices and kiosk printing services, borderless prints can often cut off the top and bottom of your image file and ruin your carefully contrived composition.

Centred with border

A better option than borderless if you want a bigger print, this style makes the edges of your image visible and confirms any compositional strengths.

Easily created in Photoshop's Print Preview menu, an even border is best produced in the printer software rather than added as an extra strip of white pixels in your image file.

Images that are automatically centred by printer software will sometimes produce uneven borders as the example above shows.

Three sides equal

This is a method useful for showing off fine prints for exhibition, especially if they are printed on tactile or cotton papers. The style is created by keeping the top, left and right borders equal and leaving a deeper one at the bottom. The process uses the print paper as a built-in window mount, with generous white space.

The style helps to evoke the print as a precious object, mimicking the look of a museum exhibit, and is ideal for preparing prints for portfolio presentation using ultra clear acetate slip-in print sleeves.

Print longevity

To keep your color prints in top condition, you need to be aware of the predicted lifespan of your chosen media and the optimum storage conditions of your final print-outs.

Media and longevity

Despite claims made on product packaging, you need to make an informed choice about media and materials right from the outset. Whereas photographic color materials have a known lifespan, new digital materials are much less predictable. With few independent voices in the field of testing and predicting the longevity of digital media, with the exception of the Wilhelm Institute in Iowa, manufacturers' claims are hard to ignore.

Yet through pioneering research using accelerated exposure to light, Wilhelm has found some very suprising results. Top of the list of non-fading materials is Epson media and pigment ink, as employed by numerous professional devices, including the PictureMate direct printing unit. With an estimated lifespan of 104 years, prints created using this purpose-made media are both water and light resistant.

Compared to the humble silver halide color print, such as the Fuji Crystal Archive paper range with an estimated life of 40 years, the new digital materials are well on their way to extending the archival properties of photography. With excellent keeping qualities aimed at even the domestic user, digital prints that are susceptible to fading will soon be a thing of the past.

Other products

Lagging somewhat behind the pigment inks and archival papers are the dye based ink families, as employed by other inkjet manufacturers. With some notable exceptions, such as those developed by HP, dye ink and media sets do not appear to last the distance.

Dye sublimation products also fall short of the lightfastness of pigment ink and pure cotton papers and should not be considered permanent.

Lesser quality media suffer from the inclusion of unstable chemical agents which can assist in the eventual breakdown of the image. Cheap dyes and bleach-impregnated papers are the two biggest culprits in this area, with the problem greatly extended when using third party manufactured products.

Despite the claims made for cheaper media, poor quality ink cartridges will often create prints that can fade in under a year, leaving a shocking color imbalance where the remaining ink on the page is the most lightfast of the pack.

Budget inks may also clog up your printer heads, owing to their much less sophisticated mode of manufacture, and should be treated with caution. Never consider using these type of products if there's the slightest chance they could invalidate the warranty of your desktop printing device.

Storage conditions

Just like silver based photographic prints, digital color prints are susceptible to damage from environmental conditions. Top of the list is light, both natural and artificial, which will reduce the lifespan of your prints if exposure is excessive. Never display your prints in direct sunlight as they will suffer within a relatively short time.

Atmospheric pollutants can also take their toll, with exposure to ozone creating the biggest threat to your work. If prints are to be displayed, they must be housed correctly in a sealed frame, safe from environmental dangers. Ensure that your print surface does not sit permanently against the glass of your frame, as condensation and humidity could result in damage to the print surface.

All prints, whether they are digital or silver based, should be stored in an acid free storage box within inert polyacetate protective sleeves for maximum lifespan. Protected from light and atmospheric pollutants, protective sleeves allow the print to expand and contract as it responds to external temperature fluctuations.

Never subject a print to any kind of adhesive during framing and mounting, using simple acetate photo corners as an invisible fixing method.

Jargon buster

Actions

Actions is a useful function of Photoshop that allows you to play a pre-recorded sequence of commands over an image or a folder of images. Photoshop has a number of basic actions included as standard, but you can easily record your own and you can even assign a function key to an action for a one-click fix.

Active Layer

In a multi-layer image file, the active layer is denoted by a blue background color in the Layers palette. Any editing will be restricted to the contents of this layer, excluding all others.

Adjustment layers

Unlike normal pixel containing layers, Adjustment layers contain only settings. They work by 'floating' common commands such as Levels and Curves over your pixel layers. No extra file data is created by this process and you can return to the original command and change it without overcooking your image. Adjustment layers can also be partially erased, so you can apply a command to a much smaller area.

Adobe Online

A useful direct link to the Adobe website from within your Photoshop application, providing you have an Internet connection. The service can provide automatic updates to fix bugs and system conflicts.

Aliasing

Square pixels describe curved shapes badly and look jagged close-up. Anti-aliasing filters and software lessen the effects of this process by reducing contrast at the edges.

Alpha channel

Created when a selection is saved, an alpha channel is a simple black and white channel that can be edited independently from your image. Found and stored in the Channels palette, alpha channels can be used in some filtering effects such as Lighting.

Anchor points

Anchor points are an essential component of paths created by the pen tool. These individual points plot the route of an outline and can be easily moved or rearranged to make a better fit.

Apply Image

This command allows you to blend one layer and channel with another layer and channel within the same image file. Both transparency and blending options can be used in this command.

Art History brush

The Art History brush converts a selected history state to a stylized brush mark. With a wide range of styles, size and blends, the Art History brush can be used for making radical painterly effects on your photographs.

Artefacts

By-products of digital processing, like noise, which degrade image quality.

Assign Profile

A method of color management when the color profile of an alien file is discarded and replaced by the default color profile of the application. Used to ensure accurate color reproduction in a professional workflow.

Audio annotation tool

An innovative tool for adding a sound clip to a Photoshop file. Useful for making comments or recording messages via a PC microphone. This component of an image file is not backwards compatible and will only playback in a PC with a sound card.

Auto Contrast

This command sets the darkest and lightest parts of an image to black and white. During the process, the first 0.5% of each extreme is ignored to create a much more realistic end result.

Auto Levels

Like the Auto Contrast command, Auto Levels maps the extreme values of an image to black and white, but does this on each individual color channel, making for a much more accurate result.

Automate

The Automate functions in Photoshop are used for applying preset commands to a batch of image files. Web Gallery and Contact Sheet are two time-saving routines for photographers.

Background color

The background color is identified in the toolbox, lying behind the square foreground color box. New canvas size adjustments are always created in the current background color.

Background printing

A way of letting an image document print while still retaining the ability to work in the current application.

Batch Processing

Using a special type of macro or Action file, Batch Processing automatically applies a sequence of preset commands to a folder of images.

Bicubic interpolation

The best method of resampling photographic pixel images. New pixel color is determined by the colors of original surrounding pixels. Resampled images can lose sharpness if enlarged or reduced excessively.

Bit

A bit is the smallest unit of data representing on or off, 0 or 1, or black or white.

Bit depth

Also referred to as color depth, this describes the size of color palette used to create a digital image, e.g. 24-bit.

Bitmap image

A bitmap is another term for a pixel based image arranged in a chessboard-like grid.

Bitmap image mode

Bitmap image mode can display only two colors, black and white, and is the best mode to save line art scans. Bitmap images have a tiny file size.

Blending modes

Digital images can be blended with each other by mixing and merging different layers together to create contrast and color enhancements.

Blur filters

There are seven blur filters in Photoshop: Blur, Blur More, Lens Blur, Gaussian Blur, Motion Blur, Radial Blur and Smart Blur. All work by merging the colors of adjoining pixels together to give the visual impression of unsharpness.

Brightness

All digital images have a measurable brightness along a 256 step scale, where black is 0 and white is 255. Both Curves and Levels commands can be used to manipulate image brightness.

Byte

Eight bits make a byte in binary numbering. A single byte can describe 0–255 states, colors or tones.

Calculations

This command allows you to merge and blend two individual channels from a number of different source images. This technique is mostly used when creating complex outline selections from different color channel information.

Canvas Size

The Canvas Size command adds new pixels to your image, so you can increase the area of your design. Extra canvas is always created in the current background color.

Card reader

Digital cameras are sold with a connecting cable that fits into your computer. A card reader is an additional unit with a slot to accept camera memory cards for faster computer transfer.

CCD

The charged coupled device is the light-sensitive 'eye' of a scanner and 'film' in a digital camera.

CDR

Compact disk recordables store digital data and are burned in a CD writer. With a capacity of 640Mb, CDRs are an economical way to store digital images.

CDRW

Compact disk rewriteables can be used many times, unlike CDRs which can only be burned once.

Channels

Channels are a hidden part of each image file which contain the color information, displayed in the Channels palette as individual red, green and blue components plus an all in one composite RGB. Editing an individual channel, rather than the composite RGB, is a good way of making a complex selection.

Channel Mixer

The Channel Mixer is a useful tool for remixing original colors in an image file. It's also used for making eye-catching conversions from RGB to monochrome without the characteristic low contrast associated with a simple mode change.

CIS

Contact image sensor is a recent alternative to CCD in scanning technology, giving higher resolution values but using different measuring criteria.

Clipping

Clipping occurs when image tone close to highlight and shadow is converted to pure white and black during scanning. Loss of detail will occur.

Clipping path

A clipping path is an embedded outline that is saved and stored with image files used in litho printing. The path is created by the Pen tool and is used for making cut out images in a page layout.

Clone Stamp tool

The Clone Stamp tool is used for retouching small blemishes in a digital image. It works by first identifying a sample point, then copies and pastes this area onto the end of a brush.

CMYK image mode

Cyan, Magenta, Yellow and Black (called K to prevent confusion with Blue) is an image mode used for litho reproduction. All magazines are printed with CMYK inks.

Color range

The color range dialog is a sophisticated tool for making a selection based on color rather than area. In addition to target colors, the dialog also offers a Fuzziness slider for growing or contracting the selection.

Color Sampler tool

The Color Sampler tool is a useful gadget for detecting color values within your image. Like a mini densitometer, the samplers can be attached to critical areas of your image to provide a live read out.

Color space

RGB, CMYK and LAB are all different color spaces with their own unique kinds of characteristics and limitations.

Colorize

The Colorize command is found within the Hue/Saturation dialog box and offers a one stop method for toning color images. Image color can be changed by moving the Hue slider and intensity controlled by the Saturation control.

Compression

Crunching digital data in smaller files is known as compression. Without physically reducing the pixel dimensions of an image, compression routines devise compromise color recipes for groups of pixels, rather than individual ones.

Conditional mode change

A by-product of working with automated actions is the ability to change the current image mode to another, all within the sequence of the action. Much used when converting from grayscale to RGB within an action.

Contact Sheet

An automated action that creates a page layout with tiny thumbnails of all the images within a designated folder. Like a traditional photographers contact sheet, it is used to provide a printed preview of all images for a later edit. An essential part of cross referencing your files is to include the filenames in the contact sheet print-out.

CPU

The central processing unit is the engine of a computer, driving the long and complex calculations when images are modified.

CRT

A cathode ray tube is the light-producing part of a monitor.

Curves

Curves is a versatile tool in the form of a histogram for adjusting contrast, color and brightness.

Custom color table

Used when working with web graphics, the custom colour table is a palette of colors which is preserved with the image file. This ensures colors are not changed or converted when viewed across a network.

Descreening

The removal of a halftone pattern from a lithographic image during scanning. This avoids a moiré effect when output.

Diffusion dithering

A dithering technique allocates randomly arranged ink droplets, rather than a grid, to create an illusion of continuous color.

Digital Zoom

Instead of pulling your subject closer, a small patch of pixels is enlarged or interpolated to make a detail look bigger than it really is.

DIMM

Dual Inline Memory Modules are a kind of RAM chip, sold with different capacities, e.g. 128Mb, and with different speeds.

Dithering

A method of simulating complex colors or tones of grey using few color ingredients. Close together, dots of ink can give the illusion of a new color.

Dot pitch

A measure of how fine is the shadow mask of a CRT monitor. The smaller the value, the sharper the display.

DPI (printer)
Printer DPI is an indication of the number of separate ink droplets deposited by a printer. The higher the number, the more photo-real results will look.

DPI (scanner)
Dots per inch measure the resolution of a scanner. The higher this number is, the more data you can capture.

Driver
A small software application that instructs a computer how to operate an external peripheral like a printer or scanner. Drivers are frequently updated but are usually available for free download from the manufacturer's website.

Dropper tools
Pipette-like icons that allow the user to define tonal limits such as highlight and shadows by directly clicking on image areas.

Duotone
A duotone image is constructed from two different color channels chosen from the color picker. It can be used to apply a tone to an image.

Dye sublimation
A kind of digital printer that uses a CMYK pigment-impregnated donor ribbon to pass color onto special receiving paper. Much less versatile than an inkjet printer.

Dynamic range
A measure of the brightness range in photographic materials and digital sensing devices. The higher the number, the greater the range.

EPS
Encapsulated Postscript is a standard format for an image or whole page layout, allowing it to be used in a range of applications.

File extension
The three or four letter/number code that appears at the end of a document name, preceded by a full stop, e.g. landscape.tif. Extensions allow applications to identify file formats and enable cross-platform file transfer.

FireWire
A fast data transfer system used on recent computers, especially for digital video and high-resolution image files. Also known as IEEE1394.

Gamut
A description of the extent of a color palette used for the creation, display or output of a digital image.

GIF
Graphics interchange format is a low-grade image file for monitor and network use, with a small file size owing to a reduced palette of 256 colors or less.

Grayscale
Grayscale mode is used to save black and white images. There are 256 steps from black to white in a grayscale image, just enough to prevent banding appearing to the human eye.

Halftone
An image constructed from a dot screen of different sizes to simulate continuous tone or color. Used in magazine and newspaper publishing.

Highlight
The brightest part of an image, represented by 255 on the 0–255 scale.

Histogram
A graph that displays the range of tones present in a digital image as a series of vertical columns.

ICC
The International Color Consortium was founded by the major manufacturers in order to develop color standards and cross-platform systems.

Inkjet
An output device which sprays ink droplets of varying size onto a wide range of media.

ISO speed
Photographic film and digital sensors are graded by their sensitivity to light. This is sometimes called film speed or ISO speed.

Interpolation
Enlarging a digital image by adding new pixels between existing ones.

JPEG
A lossy compression routine used to reduce large data files for easier transportation or storage. Leads to a reduction in image quality.

Kilobyte (K or Kb)
1024 bytes of digital information.

Lab image mode
A theoretical color space, i.e. one not employed by any hardware device, used for processing images.

Layered image

A kind of image file, such as the Photoshop file, where separate image elements can be arranged above and below each other, like a stack of cards.

Layer blending

A function of Photoshop Layers, allowing a user to merge adjoining layers based on transparency, color and a wide range of non-photographic effects.

Layer opacity

The visible 'strength' of a Photoshop layer can be modified on a 0–100% scale. As this value drops, the modified layer merges into the underlying layer.

Levels

A common set of tools for controlling image brightness found in Adobe Photoshop and many other imaging applications. Levels can be used for setting highlight and shadow points.

Line art

A type of original artwork in one color only, such as typescript or pencil drawings.

Megabyte (Mb)

1024 kilobytes of digital information. Most digital images are measured in Mb.

Megapixel

Megapixel is a measurement of how many pixels a digital camera can make. A bitmap image measuring 1800 x 1200 pixels contains 2.1 million pixels (1800 x 1200=2.1 million), made by a 2.1 Megapixel camera.

Noise

Like grain in traditional photographic film, noise is an inevitable by-product of shooting with a high ISO setting. If too little light passes onto the CCD sensor, brightly colored pixels are made by mistake in the shadow areas.

Optical resolution

Also called true resolution, this is a measure of hardware capability, excluding any enhancements made by software trickery or interpolation, and is usually found in the small print!

Parallel

A type of connection mainly associated with printers and some scanners. The data-transfer rate of a parallel connection is slower than SCSI or USB.

Pantone

The Pantone color library is an internationally established system for describing color with pin-number-like codes. Used in the lithographic printing industry for mixing color by the weights of ink.

Path

A path is a vector-based outline used in Photoshop for creating precise cut-outs. As no pixel data is involved, paths add a tiny amount to the file size and can be converted into selections.

PCI Slot

A peripheral component interface slot is an expansion bay in a computer used for adding extra connecting ports or performance-enhancing cards.

Peripherals

Peripherals, like scanners, printers, CD writers, etc., are items used to build up a computer workstation.

Pictrography

A type of high-resolution digital printer, made by Fuji, that images directly onto special donor paper without the need for processing chemistry.

Pigment inks

A more lightfast inkset for inkjet printers, usually with a smaller color gamut than dye-based inksets. Used for producing prints for sale.

Pixel

Taken from the words Picture Element, a pixel is the building block of a digital image, like a single tile in a mosaic. Pixels are generally square in shape.

Profile

The color-reproduction characteristics of an input or output device. This is used by color-management software such as ColorSync to maintain color accuracy when moving images across computers and input/output devices.

Quadtone

A quadtone image is constructed from four different color channels, chosen from the color picker or custom color libraries like Pantone.

RAM

Random Access Memory is the part of a computer that holds your data during work-in-progress. Computers with little RAM will process images slowly as data is written to the hard drive, which is slower to respond.

Resolution

The term resolution is used to describe several overlapping things. In general, high-resolution images are used for printing out and have millions of pixels made from a palette of millions of colors. Low-resolution images have fewer pixels and are only suitable for computer monitor display.

RGB image mode

The red, green and blue mode is used for digital color images. Each separate color has its own channel of 256 steps and pixel color is derived from a mixture of these three ingredients.

RIP

A raster image processor translates vector graphics and fonts into bitmaps for digital output. RIPs can be both hardware and software.

Selection

A fenced-off area created in an imaging application like Photoshop which limits the effects of processing or manipulation.

Scratch disk

A portion of a computer's free hard disk (or an external drive) that acts as overflow RAM during work-in-progress.

SCSI

Small computer systems interface is a type of connector used to attach scanners and other peripherals to your computer.

Shadow

The darkest part of an image, represented by 0 on the 0–255 scale.

Shadow mask

A type of finely perforated stencil that creates pixels on a CRT monitor.

Sharpening

A processing filter which increases contrast between pixels to give the impression of greater image sharpness.

Unsharp Mask (USM)

This is the most sophisticated sharpening filter, found in many applications.

USB

Universal serial bus is a recent type of connector which allows easier set-up of peripheral devices.

TIFF

Tagged image file format is the most common cross-platform image type used in the industry. A compressed variation exists which is less compatible with DTP applications.

Tritone

A tritone image is constructed from three different color channels, chosen from the color picker or custom color libraries like Pantone.

TWAIN

Toolkit Without An Interesting Name is a universal software standard which lets you acquire images from scanners and digital cameras from within your graphics application.

VRAM

Video RAM is responsible for the speed, color depth and resolution of a computer monitor display. A separate card can be purchased to upgrade older machines with limited VRAM.

White Balance

Digital cameras and camcorders have a White Balance control to prevent unwanted color casts. Unlike photographic color film, which is adversely affected by fluorescent and domestic lights, digital cameras can create color-corrected pixels without using special filters.

White out

In digital images, excessive light or overexposure causes white out. Unlike film, where detail can be coaxed out of overexposed negatives with careful printing, white pixels can never be modified to produce latent detail.

Index

Credits

Graphic design
Nina Esmund
nina@photocollege.co.uk

Images
All photographic and illustrative images
are copyright the author except:
page 1, 16, 48: courtesy of Silicon Graphics
page 10, 49: courtesy of Apple Computers
page 12, 14, 68: courtesy of Nikon
page 13: courtesy of Kodak
page 17: courtesy of LaCie
page 18, 20, 21, 23: courtesy of Epson UK
page 25: courtesy of Lyson
page 39: courtesy of Umax
pages 42–44: courtesy of Lasersoft

Software
The author would like to thank the
following for their help in providing
evaluation software for this book: Adobe,
Lasersoft and AutoFX.

Hardware
Thanks to Epson UK for their support.

Materials
Thanks to Lyson for media and continuous
ink system support.

Thanks to:
Chris Dickie at *AG: The International Journal
of Photographic Art and Practice,* for his
continuing encouragement and patience.

Eddie Ephraums at Argentum for his help and
support.

Phillip Andrews for continuing guidance and
renovations.

Further reading
Tim Daly writes regular features on digital
techniques for *AG: The International Journal
of Photographic Art and Practice.*
Quarterly by subscription only from
PictureBox Media Ltd
Dulwich Lodge, 62 Pemberton Rd, East
Molesey, Surrey KT8 9LH, UK.
website: www.ag-photo.co.uk
email: subs@ag-photo.co.uk

Contact the author
website: www.timdaly.com
email: tim@photocollege.co.uk